Dream Shot

The Journey to a Wheelchair Basketball National Championship

Josh Birnbaum

with an Introduction by Matthew E. Buchi

UNIVERSITY OF ILLINOIS PRESS
Urbana, Chicago, and Springfield

This book is dedicated to Dr. Timothy J. Nugent (1923–2015), for helping to create a more inclusive world.

FACING TITLE PAGE: Steve Serio rolls through a stream of sunlight as the wheelchair basketball team practices running up and down the Memorial Stadium ramps in Champaign, Illinois, on September 13, 2007.

FACING THIS PAGE: Players shoot hoops at practice on Sept. 6, 2006, in Urbana, Illinois, at the University of Illinois's Campus Recreation Center East.

FACING TABLE OF CONTENTS: Zach Beaulieu, Illinois wheelchair basketball player.

© 2017 by Josh Birnbaum
All rights reserved
Manufactured in the United States of America
P 5 4 3 2 1
∞ This book is printed on acid-free paper.

Cataloging-in-Publication Data available from the Library of Congress
ISBN 978-0-252-08304-4 (paper: alk.)
ISBN 978-0-252-05012-1 (ebook)

Dream Shot

To Mary Kay

Thanks for all you do teaching
students the importance of storytelling!

— Josh Chin

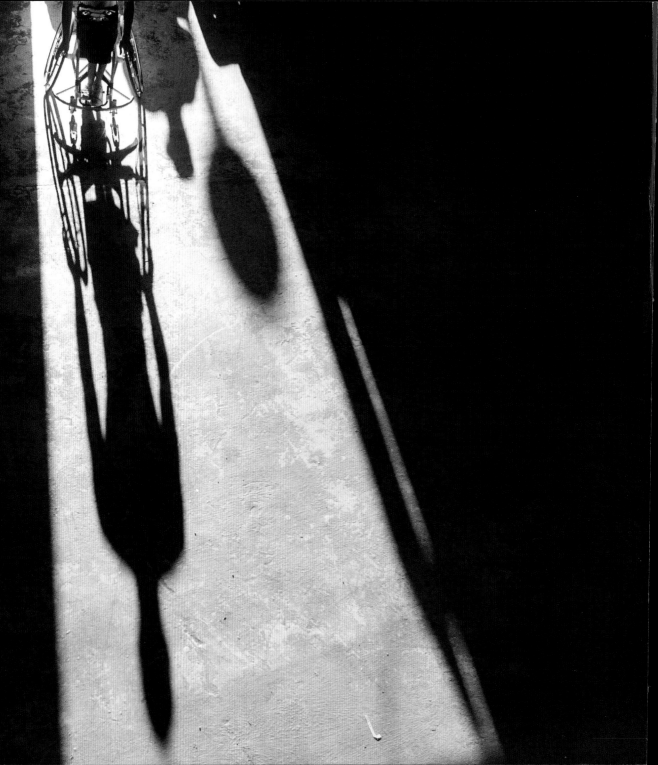

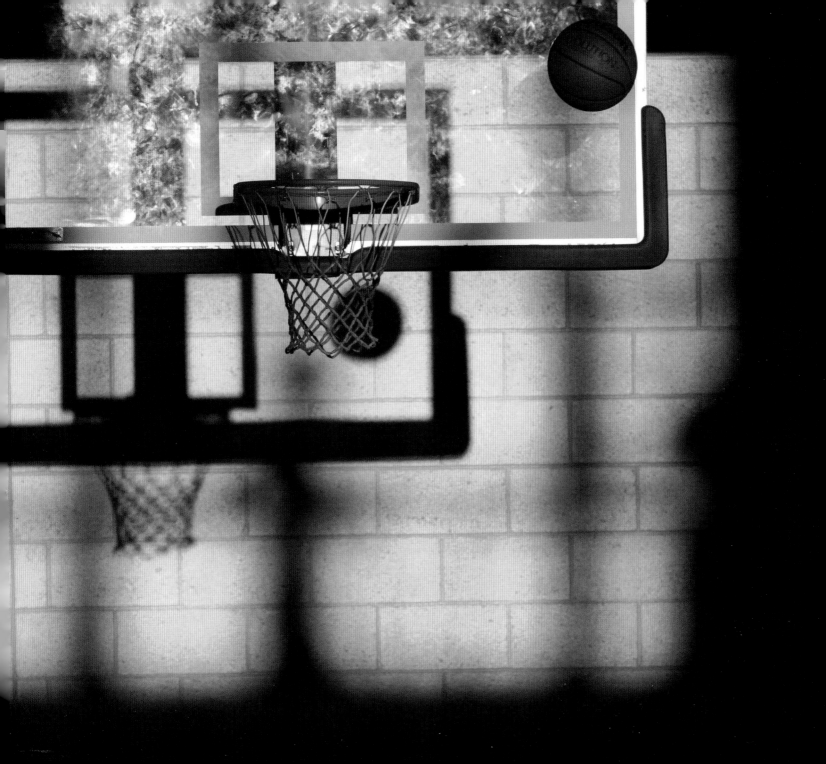

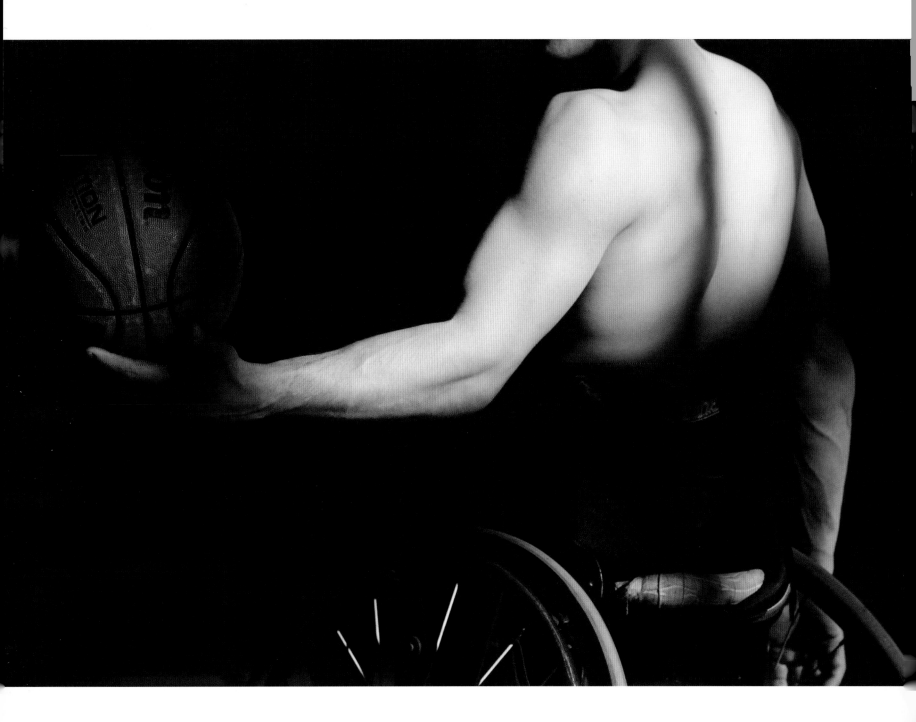

Contents

Dream Shot

Introduction

Matthew E. Buchi

In 1948, Dr. Tim Nugent established a unique program for wounded war veterans to gain independence, education, and physical literacy. Dr. Nugent eventually established that program at the University of Illinois in Urbana-Champaign. This would be the beginning of many groundbreaking changes for accessibility and disability awareness around the world. It also gave birth to wheelchair basketball in the United States. Soon after developing a few wheelchair basketball teams—including the first, the Illinois Gizz Kids—Dr. Nugent created the National Wheelchair Basketball Association (NWBA), which gave an opportunity to people with physical disabilities to play basketball competitively, on an even playing field. The NWBA now has over two hundred teams across the country, giving athletes of all ages and skill levels the chance to participate.

As an athlete with a disability, wheelchair basketball has changed my life. Disabled from an early age with a spinal cord injury, I found wheelchair basketball through another athlete who had acquired his disability from birth. He had participated in wheelchair track with a local program that had recently created a wheelchair basketball team. The chance to play a sport with other athletes who had similar but varying disabilities was an eye-opening experience. Wheelchair basketball was an outlet to be physically active, as well as a safe learning environment of life skills needed as a person with a disability.

> "Dr. Nugent created the National Wheelchair Basketball Association (NWBA), which gave an opportunity to people with physical disabilities to play basketball competitively, on an even playing field."

I was personally able to play in nearly every level of the NWBA, starting as a youngster in the Prep, JV, and Varsity divisions. Then I had the honor to play at the University of Illinois and win a college national championship in 2008. I continued to play in D3 and championship divisions while being an assistant coach and winning college national championships with the Illinois men in 2010 and the Alabama women in 2011. I was able to support Team USA women for the 2012 London Paralympics and now reside as the head coach of the Illinois men's team. Wheelchair basketball has dramatically changed my life for the better, and I know that for many other athletes in the sport, their quality of life would not be the same without it.

It was truly remarkable to have such amazing photos taken during my college career and when capturing a national championship. It's one thing to have the memories in your mind, but it's so amazing to be able to share them through images that

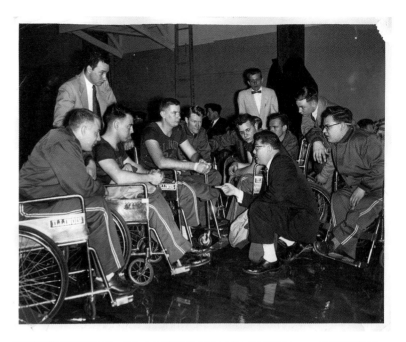

capture the feelings you had. The ups and downs and everything in between, all of it made the experience something I will never forget. My fondest memory and image is one of myself being embraced by two of my teammates immediately after winning the championship. There is so much emotion captured in that image, and I will treasure it for the rest of my life.

Now, looking back nearly ten years later, the feelings and emotions are still there. The plays and the scores may have faded from memory, and our teammates are off creating new careers, families, and lives, but we can always come back to our season through the images captured in this book. A season that will always bond me and my teammates together as a family. An Illini family.

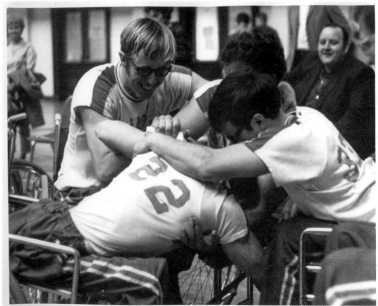

TOP: Timothy J. Nugent giving a talk to the Illinois Gizz Kids during a 1955 wheelchair basketball game. *Photo #0003378 courtesy of the University of Illinois Archives at Urbana-Champaign.*

BOTTOM: Four players from the University of Illinois men's wheelchair basketball team celebrating their victory at the 1970 National Wheelchair Basketball Tournament. *Photo #0003356 courtesy of the University of Illinois Archives at Urbana-Champaign.*

The Journey

Photographs 2005–2008

In 1948, thanks to Dr. Tim Nugent, the University of Illinois Gizz Kids became the first collegiate wheelchair basketball team in America.

More than fifty years later, this team carries on the legacy of the original Gizz Kids, striving beyond any limitations they have to play basketball. They practice every morning at 6:30 A.M. in hopes of accomplishing what every athlete wants: to win a national championship.

The photographs in this book document the experience of being a wheelchair athlete: from practice, to games, to being on the road, to moments with teammates and coaches, through struggle and challenge, onward to realizing their hoop dreams.

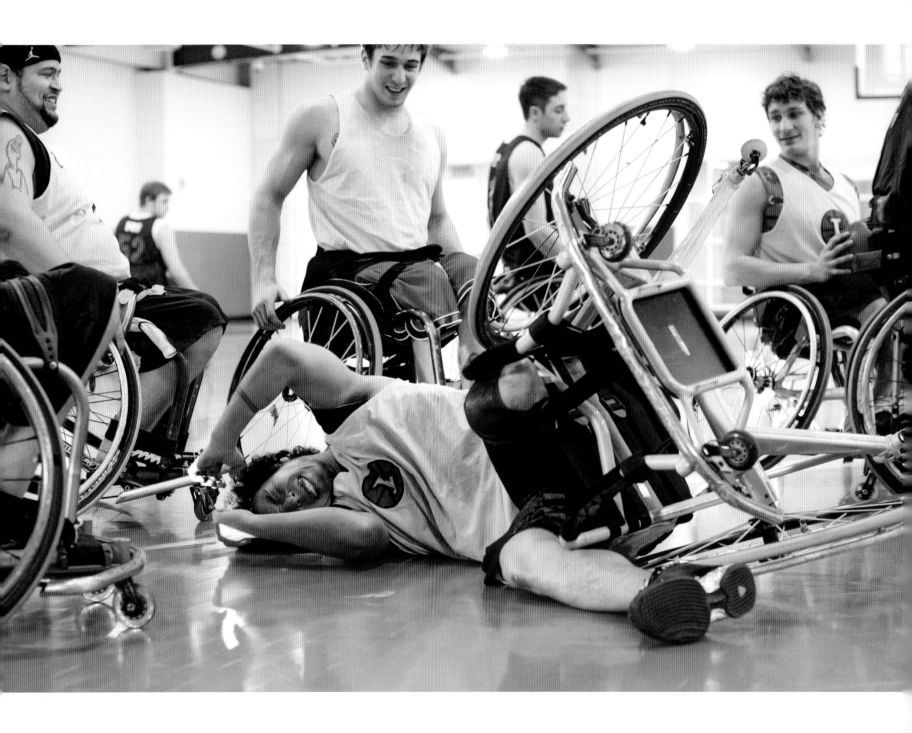

Practice

"

Whoever wants to reach a goal must take many small steps. Every day at practice, we take small steps.

"

—Mike Frogley, Head Coach, 1997–2013

Wataru Horie, a player from Japan, grimaces and laughs with his teammates after falling over in his chair at practice. Frequently, players lose control of their chairs and fall, roll, or flip, but they can quickly push themselves up again and resume playing.

After playing two games in a row at a University of Wisconsin-Whitewater tournament, Denny Muha's hands show calluses, peeling skin, and caked-on dirt. His hands get dirty from pushing his wheelchair. "Some courts are dirtier than others," Muha remarked.

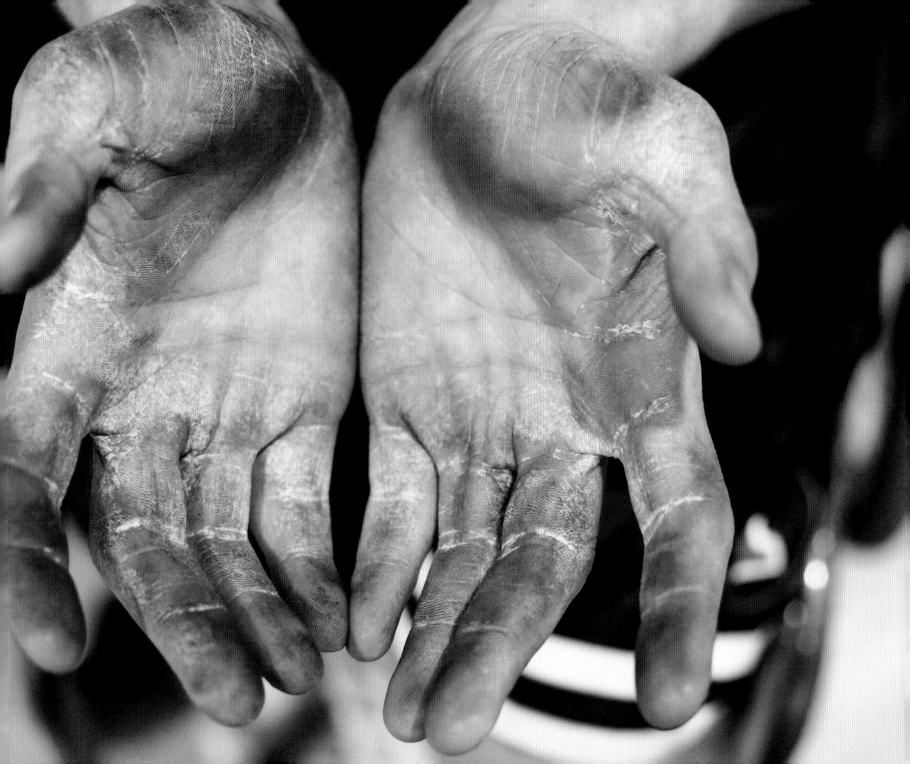

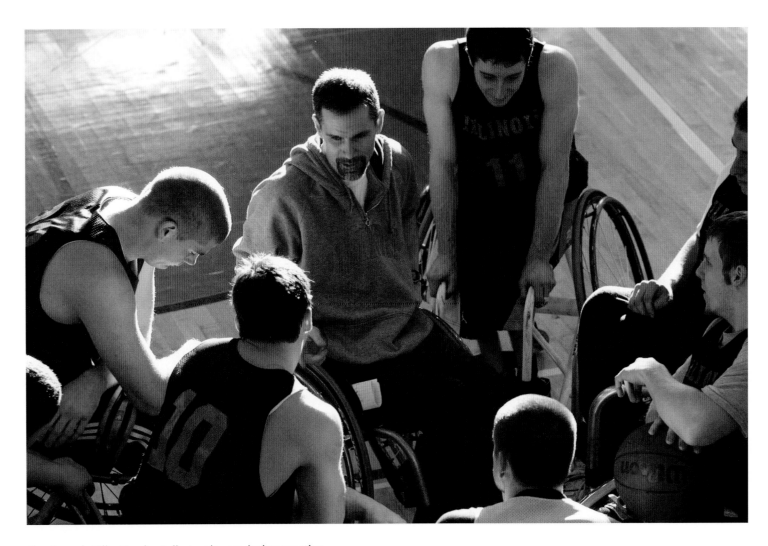

Head coach Mike Frogley talks to players during practice. "He knows when to yell and when to praise," Brandon Wagner said. "He always seems to know the right call, in practice or in a game."

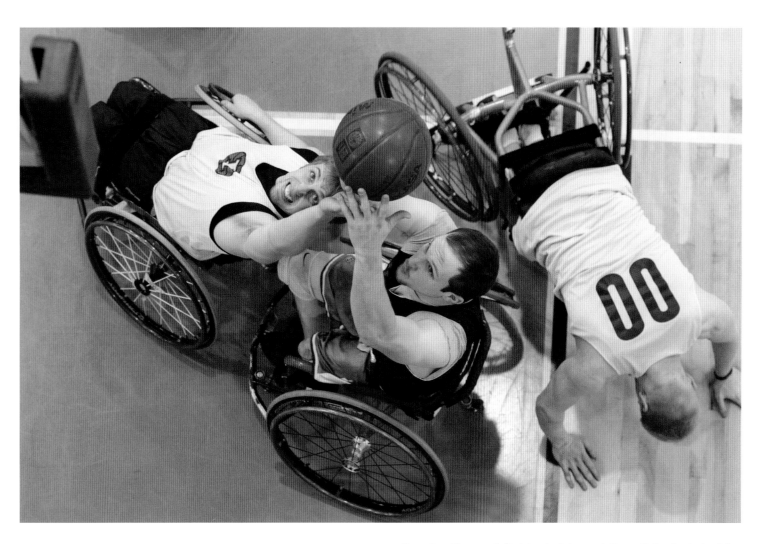

Brandon Wagner, left, tries to intercept Drew Dokos's shot while Matthew E. Buchi lifts himself up. "The smallest guy on the court can keep the biggest, fastest guy out of the court just by having good chair position," head coach Mike Frogley said. "A pick and roll in wheelchair basketball is the most deadly way to score."

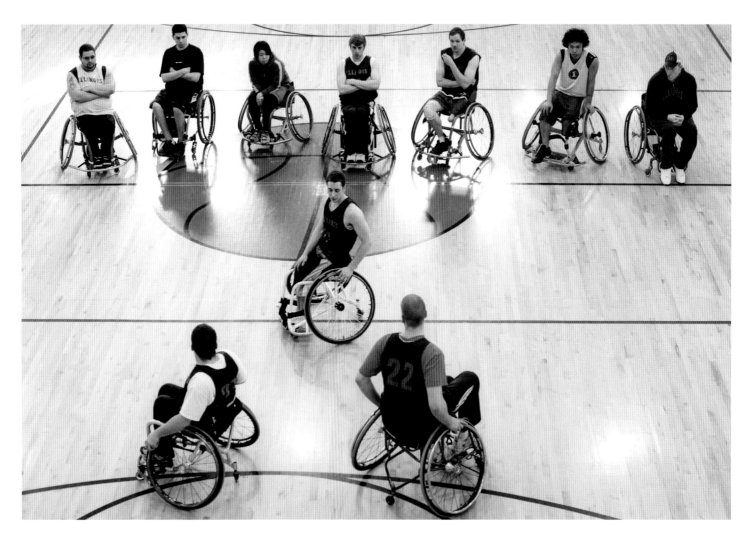

Players practice formations and shooting skills at drill. "The big strategic difference is that because you can't step sideways in wheelchair basketball because of your chair, because you don't have lateral movement, position is everything," head coach Mike Frogley said.

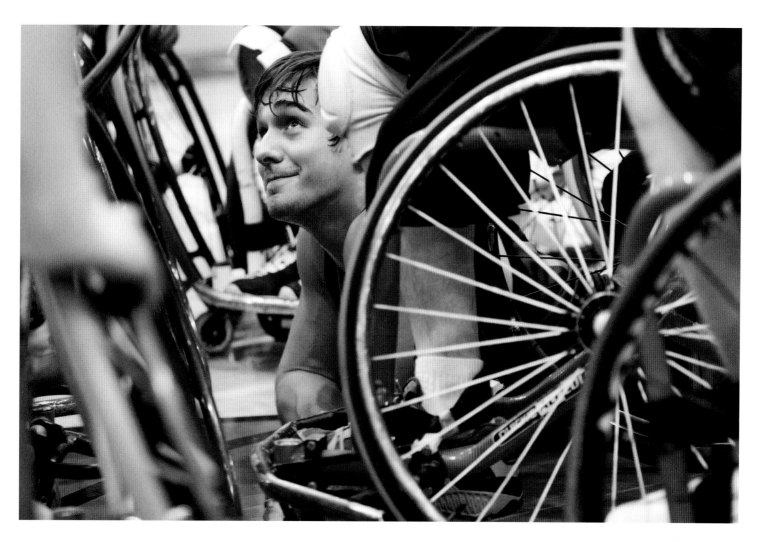

Zach Beaulieu lies on the ground as the team listens to head coach Mike Frogley during practice. Beaulieu had to sit out of practice due to a pressure sore.

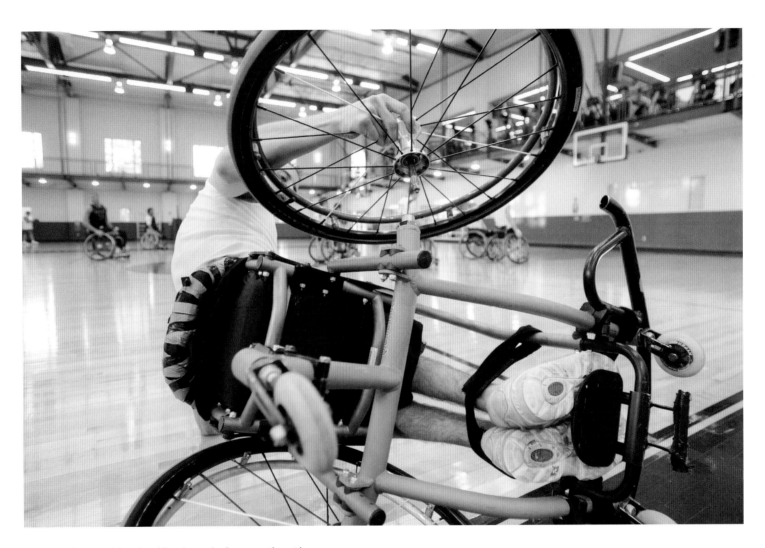

Steve Serio puts his wheel back on during practice. Players frequently need to perform maintenance on their chairs as a result of the daily wear and tear.

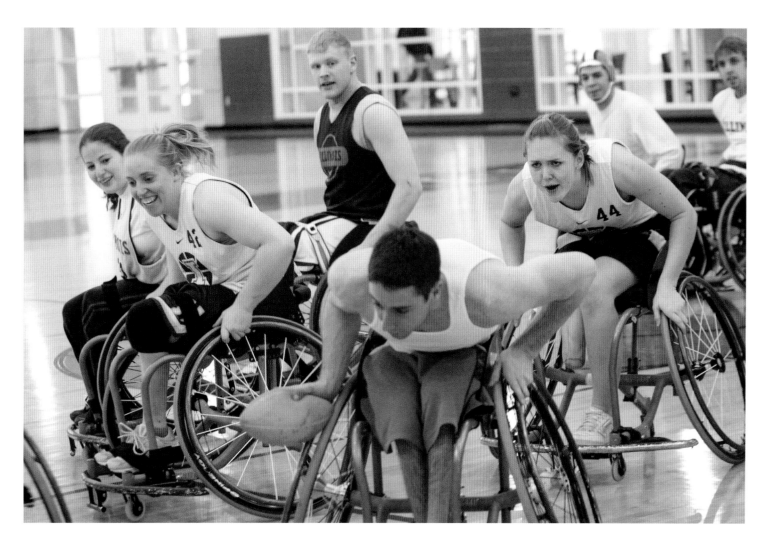

From left, Dana Fink, Shelley Chaplin, Matthew E. Buchi, Steve Serio, and Kathleen O'Kelly-Kennedy scrimmage during practice. The women's team often practices with the men's team.

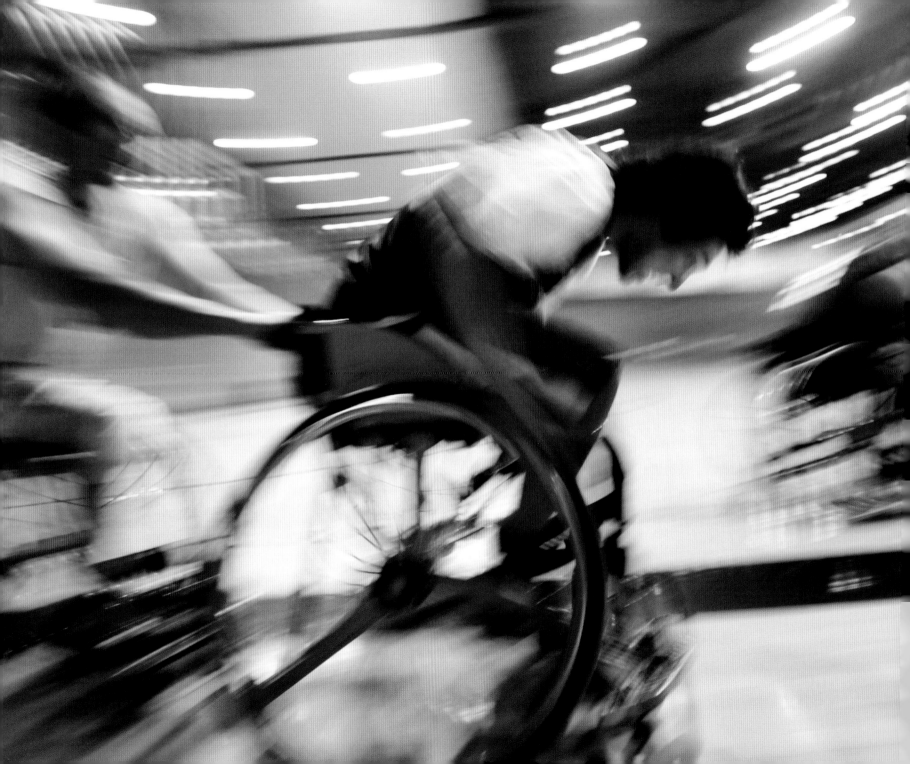

Wataru Horie sprints during practice as part of a warm-up exercise. Every practice is comprised of a warm-up, stretching, exercises, and then a scrimmage.

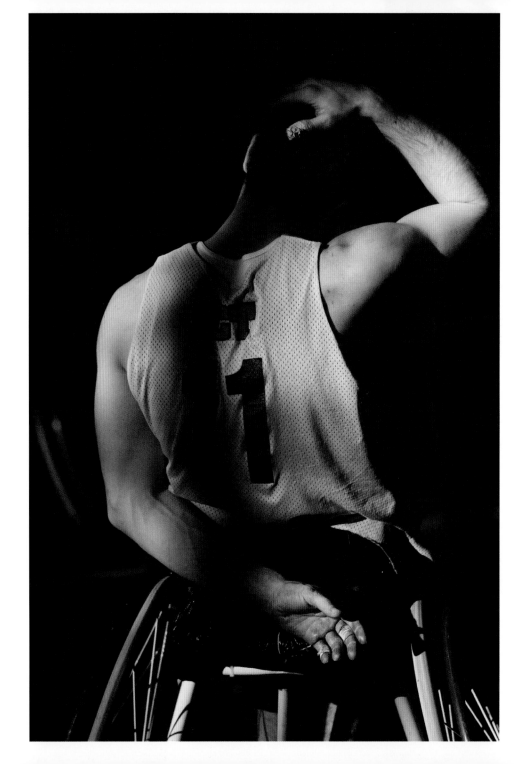

Steve Serio stretches at the end of an exhausting workout.

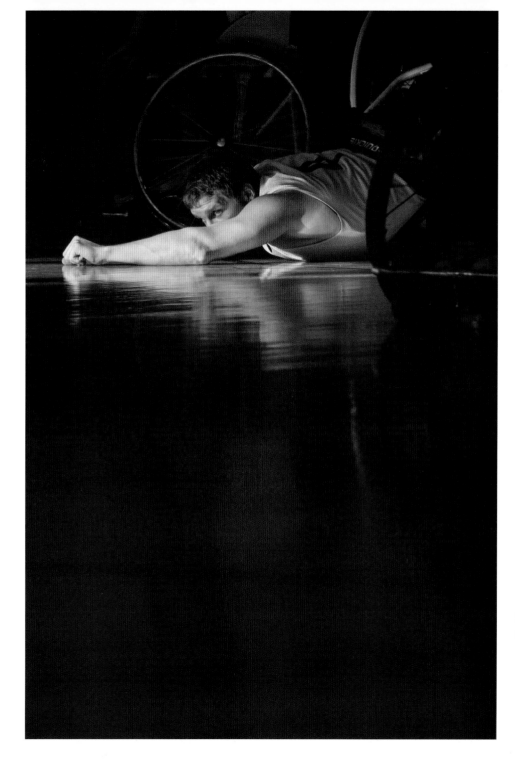

Denny Muha looks up after falling on court during a scrimmage.

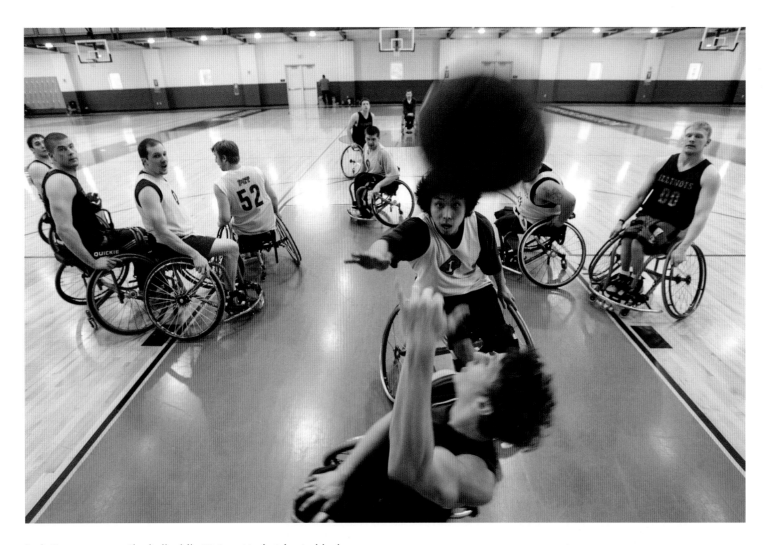

Josh George passes the ball while Wataru Horie tries to block during a scrimmage. "You can really see on the court that the trigger for our game is our defense," head coach Mike Frogley said. "When we come out and we're playing good defense together, we force other teams to make bad passes and bad shots."

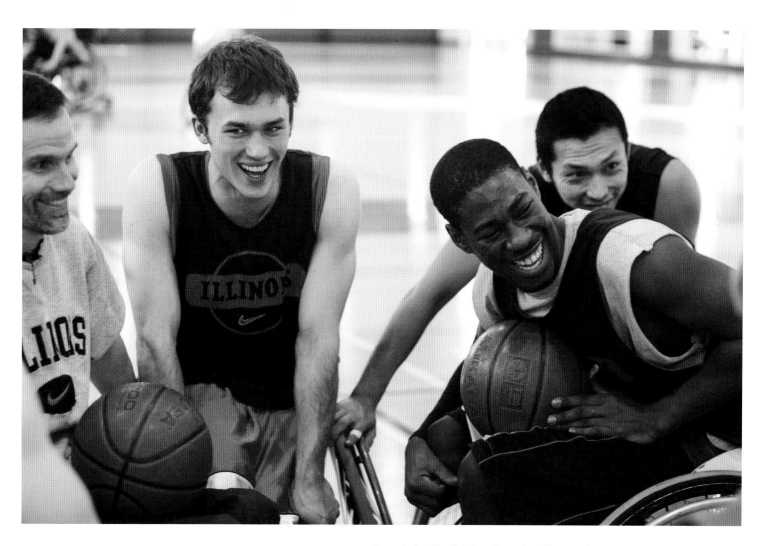

From left, Illinois's head coach Mike Frogley, Tom Smurr, Brian Bell (front), and Wataru Horie (back) laugh together during practice. Both Smurr and Bell are freshman on the team. "Our rookies are so talented that the potential for this team in the next three to four years is just unbelievable," team captain Steve Serio said. "They could be one of the great college teams ever because these rookies are so good."

Steve Serio listens as head coach Mike Frogley speaks to the team during practice. "It's more or less a mind game—trying to keep ourselves mentally prepared for the next game," Tom Smurr said.

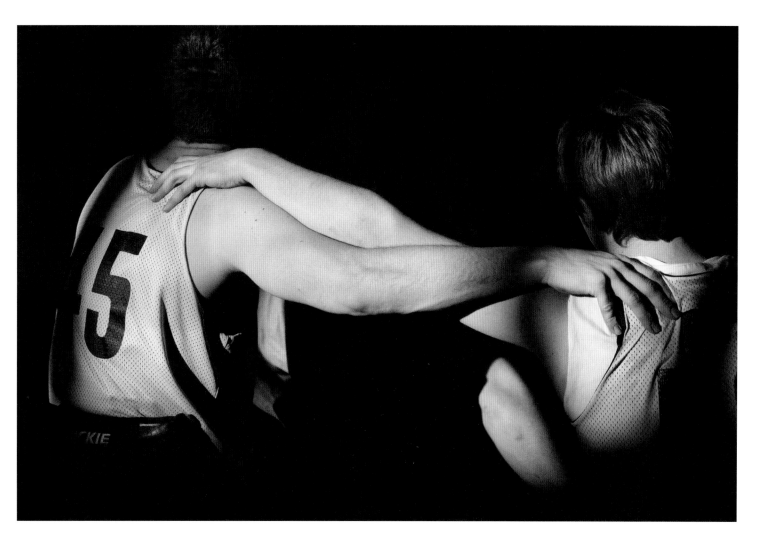

Jeff Townsend, left, and Brandon Wagner interlock arms as part of a team huddle at the end of practice.

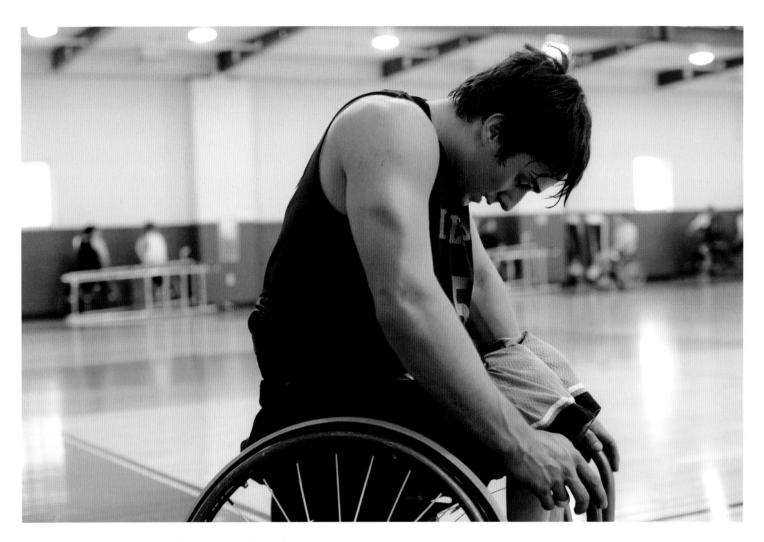

Zach Beaulieu rests after a difficult series of exercises.

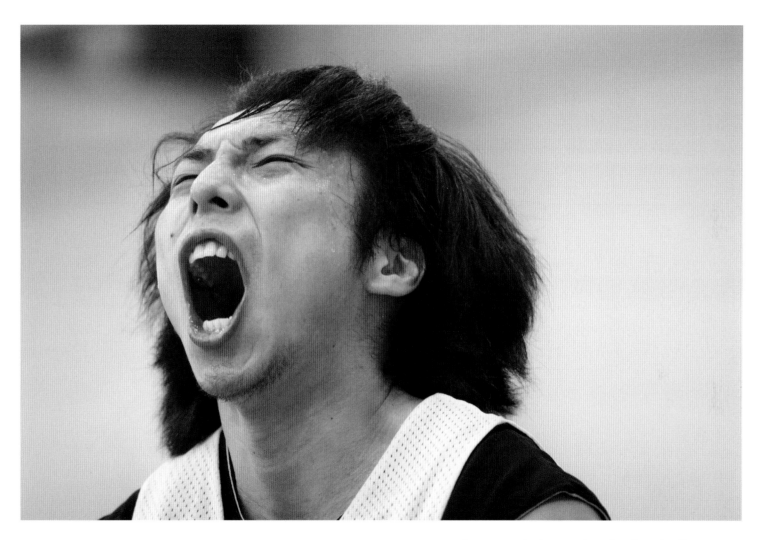

Wataru Horie screams during a series of push and pull
wheelchair resistance exercises that blistered his hands.

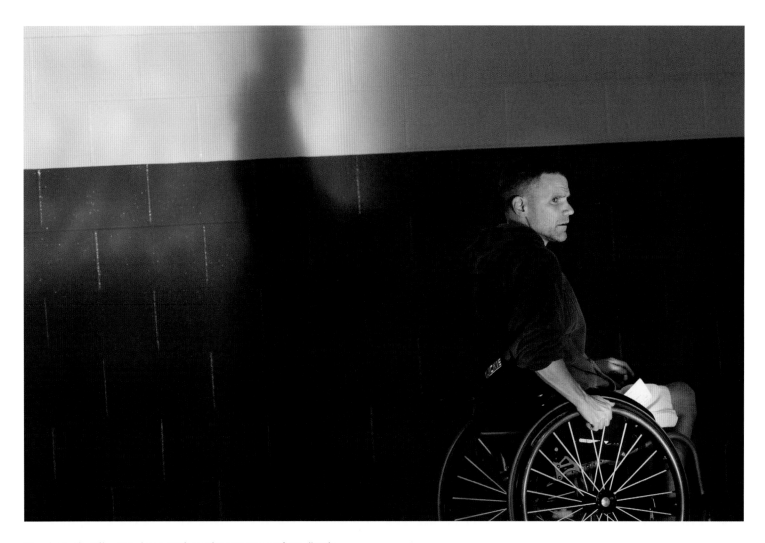

Head coach Mike Frogley watches players run sprints. "He's definitely like a father figure in my life," Denny Muha said. "I definitely look up at him and have so much respect for him. He's always been there for me as a great coach, but he's always made sure that I know that if there's anything I need, he's always got my back on it. Anything at all."

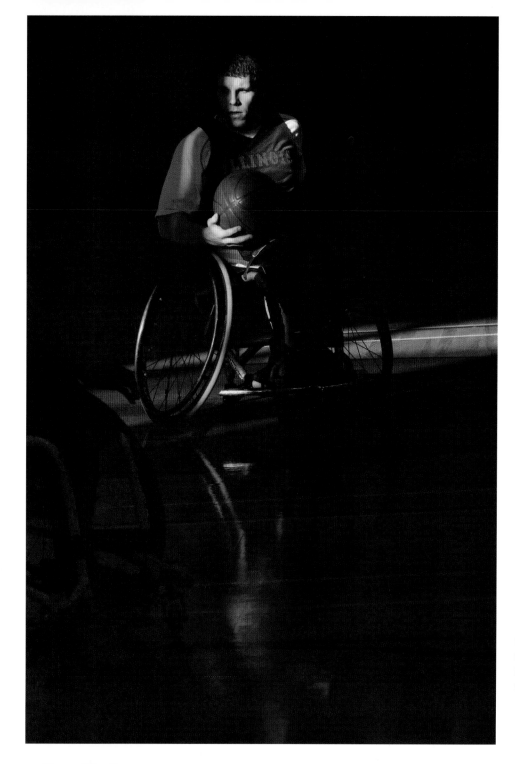

Denny Muha leads the ball down court during practice. "I look on Denny . . . I look on him like a son," head coach Mike Frogley said. "I love coaching him. There's a lot of parts of our personality that are the same."

Wataru Horie pushes his chair up the ramps of Memorial
Stadium in the early morning hours. Every Thursday in
September is ramp practice for the team. The intensive workout
requires players to push their chairs forward up the ramps,
push their chairs backward up the ramps, and then push and
instantaneously stop on loop for the last segment of exercises.

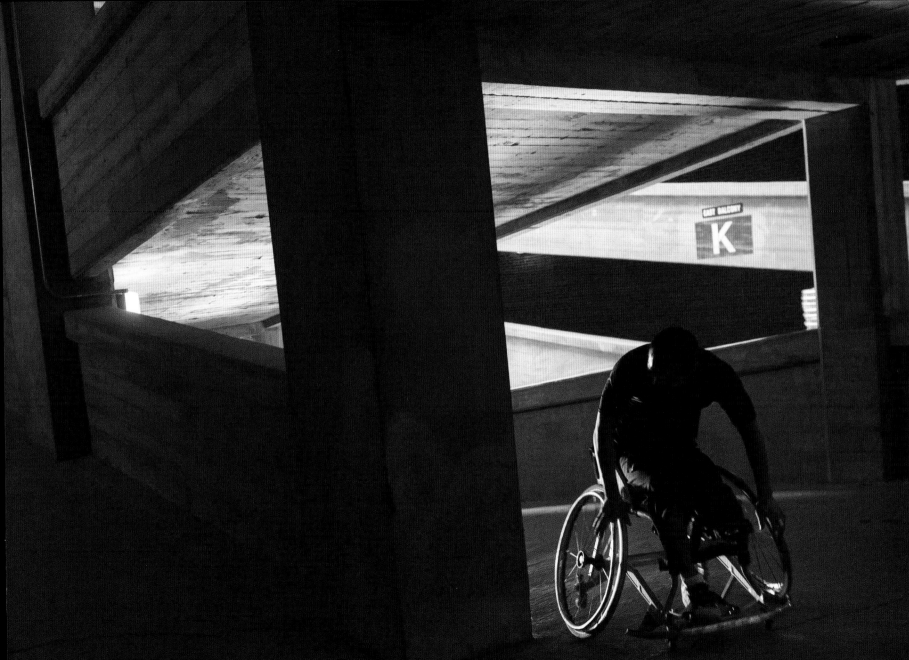

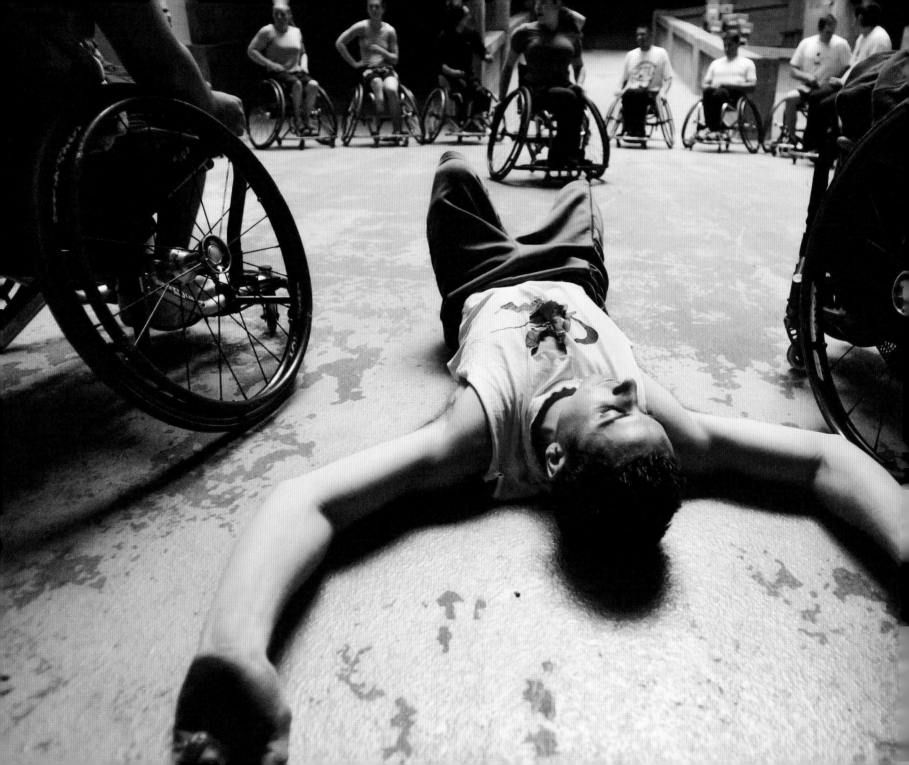

Steve Serio rests on the ground after the team sprinted up and down ramps at Memorial Stadium in Champaign, Illinois.

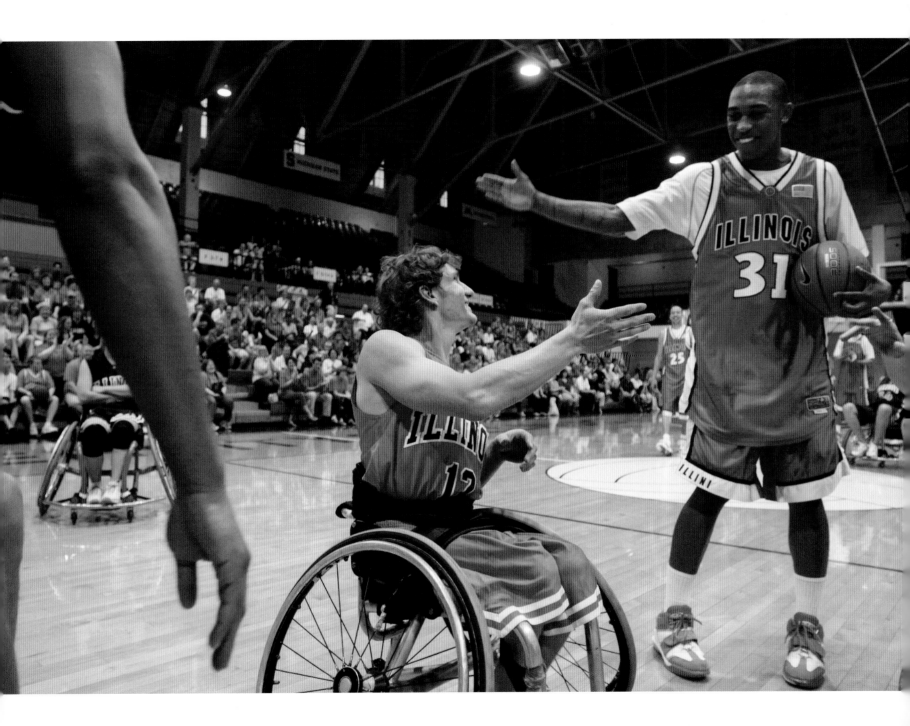

Off the Court

"

They're a microcosm of society in many respects: the world is becoming a global community, and these guys are from all over the place, and they get along. They celebrate their differences. I'd like to see the whole world get to that point.

"

—Mike Frogley, head coach

Illinois's Jamar Smith high-fives Illinois's Josh George after George won the three-point shooting contest during halftime of the first annual Ultimate Basketball Challenge at Huff Hall in Champaign, Illinois, on April 12, 2006. The match paired up Illinois able-bodied teams with the men's and women's wheelchair basketball teams for a wheelchair game. The event had over seven hundred attendees.

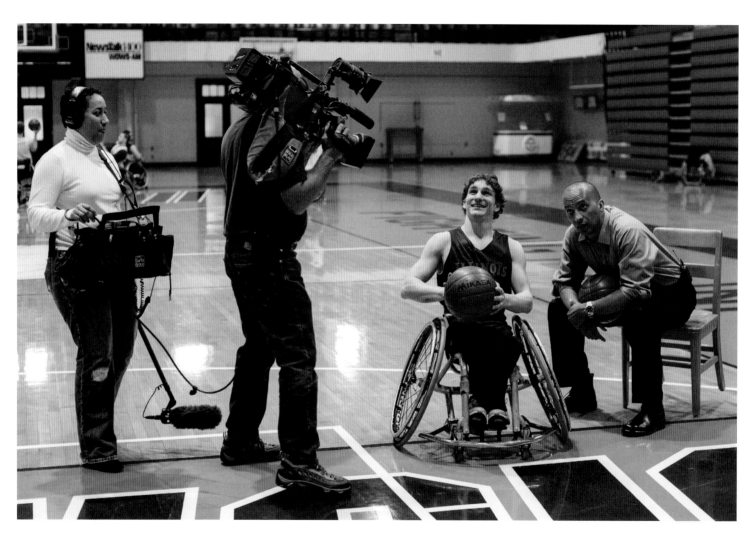

A local news station interviews Josh George about his
three-point shooting ability at Huff Hall.

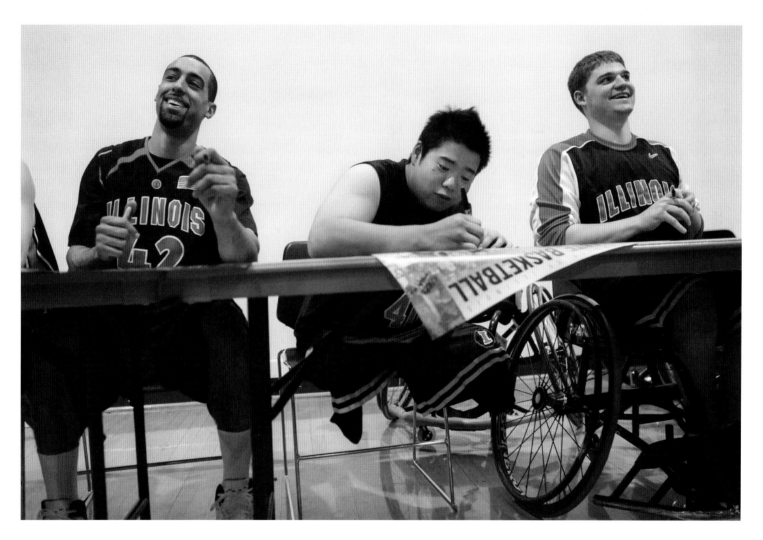

Illinois's able-bodied player Brian Randle, left, Hiroaki Kozai, center, and Joey Gugliotta sign autographs before the Ultimate Basketball Challenge on Wednesday, April 16, 2008. This was the third annual exhibition game, which was organized to raise awareness of wheelchair basketball and to raise funds for Coaches vs. Cancer.

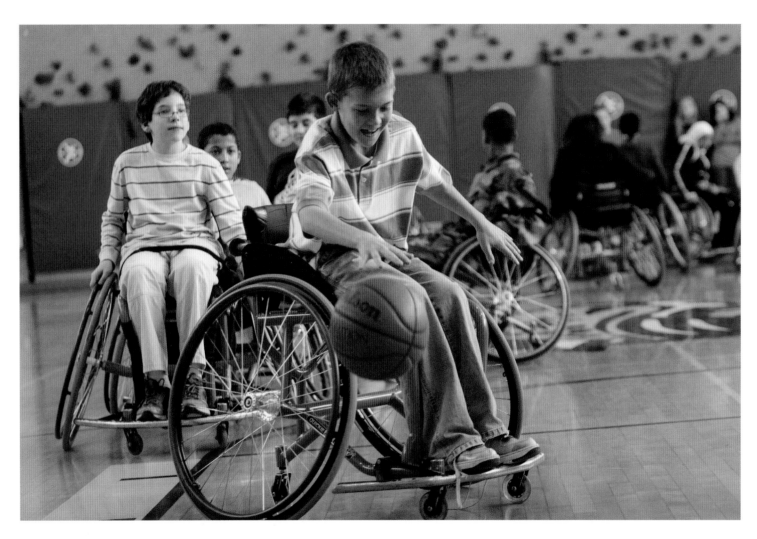

Cayden Bergschneider, student at Jefferson Middle School in Champaign, Illinois, tries to dribble the ball while in a demo wheelchair on April 5, 2007, at the school during a wheelchair basketball exhibition. The Illinois wheelchair basketball teams put on the exhibitions to educate and inform able-bodied students during April, which is Disability Awareness month.

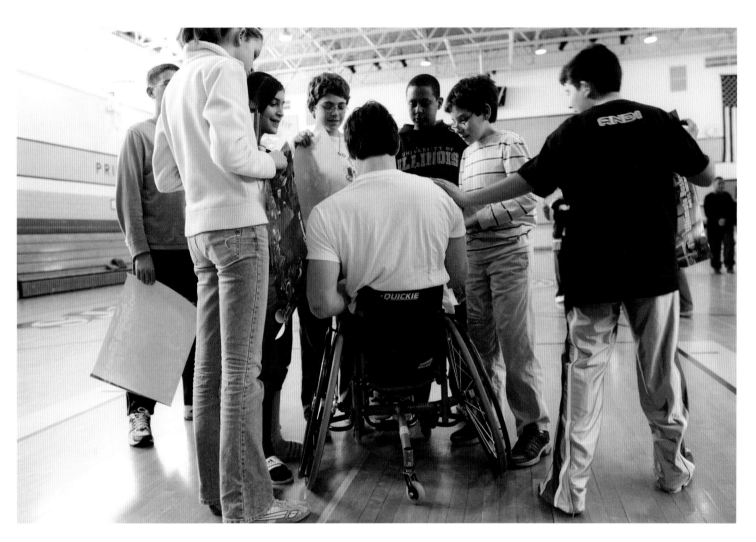

Illinois wheelchair basketball player Zach Beaulieu signs posters for Jefferson Middle School students after the exhibition.

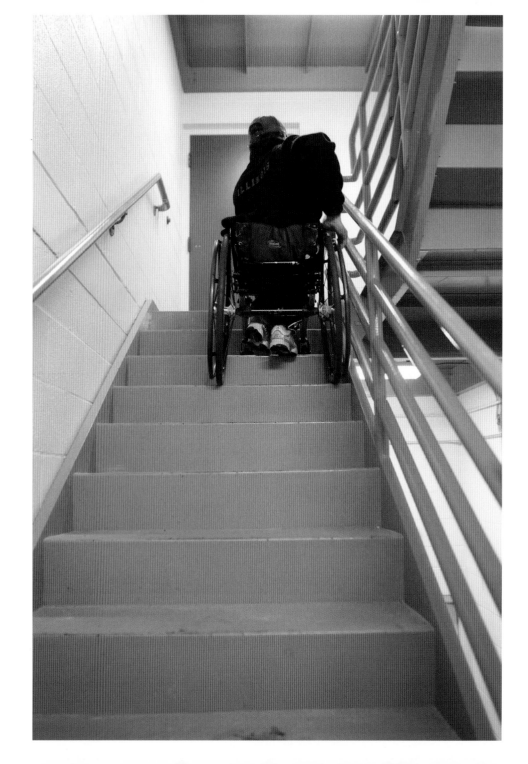

Josh George lifts himself up a set of stairs at his hotel.

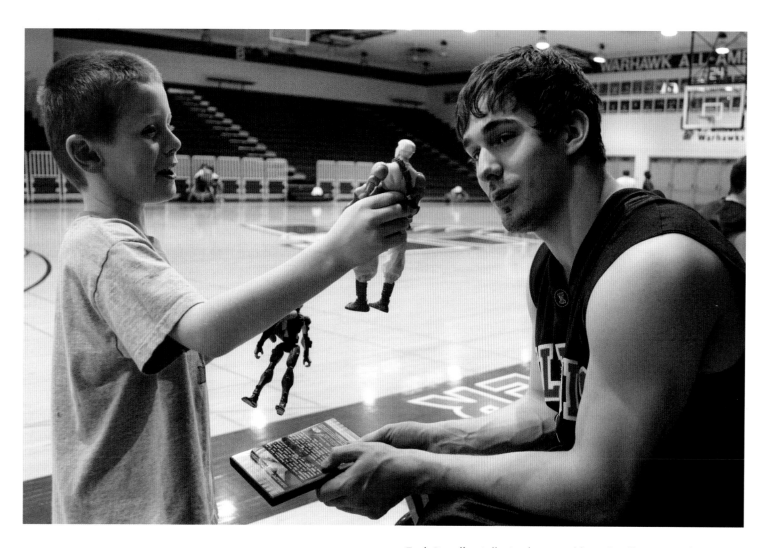

Zach Beaulieu talks to six-year-old Jacob Wilson, son of Milwaukee Bucks wheelchair basketball coach Steve Wilson, about his action figures during a wheelchair basketball tournament at the University of Wisconsin-Whitewater.

Denny Muha, left, and head coach Mike Frogley visit player Matthew E. Buchi at Carle Hospital. Buchi suffered from a staph infection and was not able to play until he recovered. Muha and Buchi have been friends since childhood.

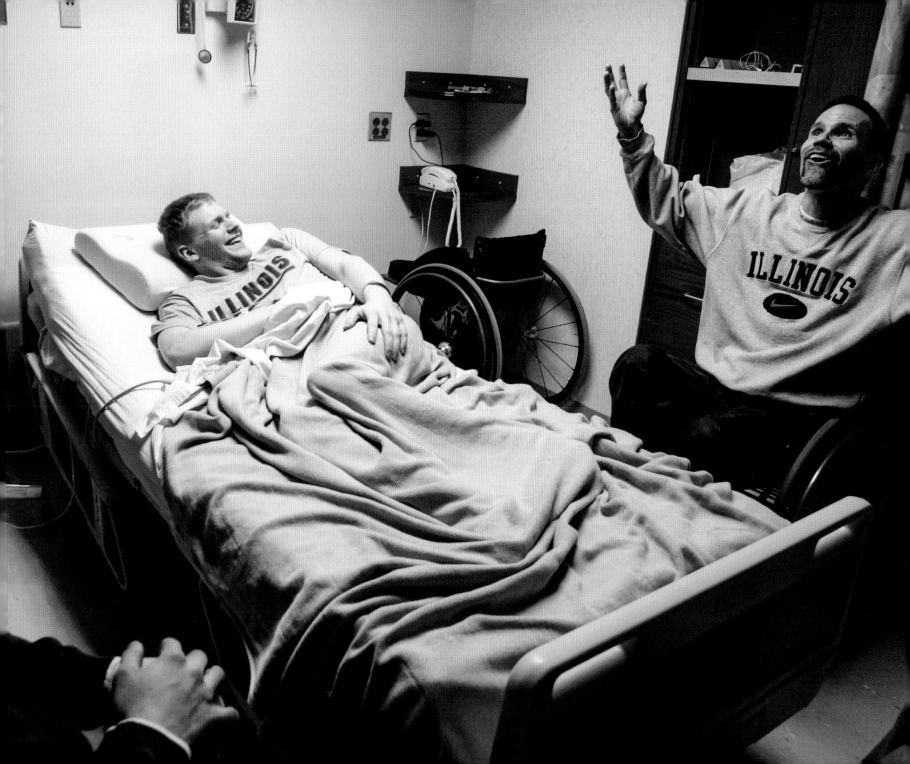

Denny Muha reaches down to pick up a pencil during his class at the University of Illinois at Urbana-Champaign. Muha earned his bachelor's in recreation, sport, and tourism, and his master's in human resource management.

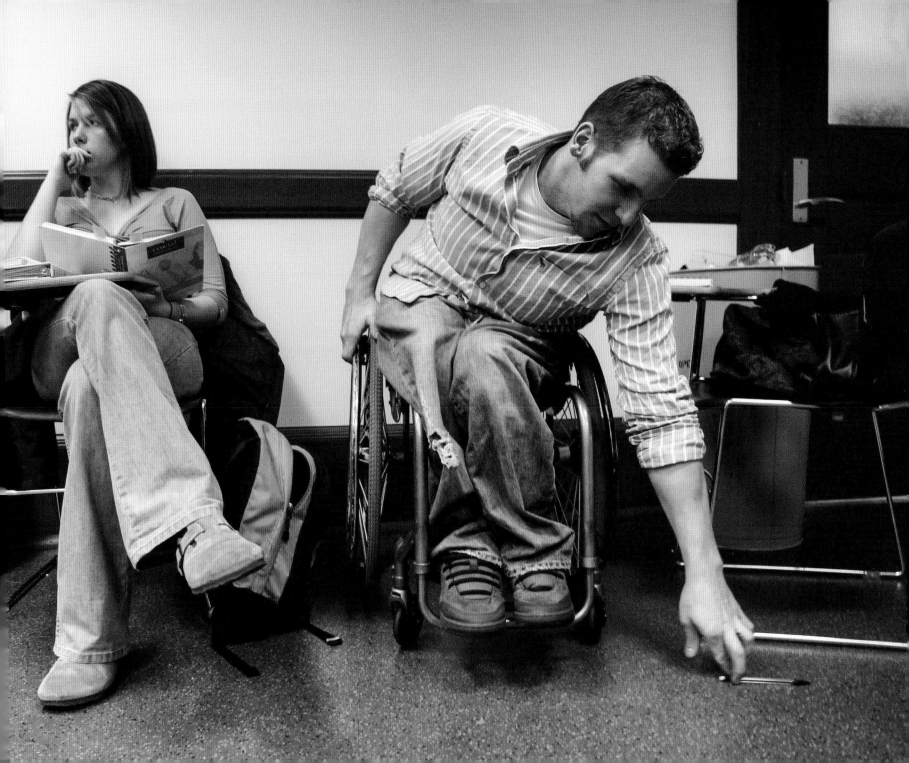

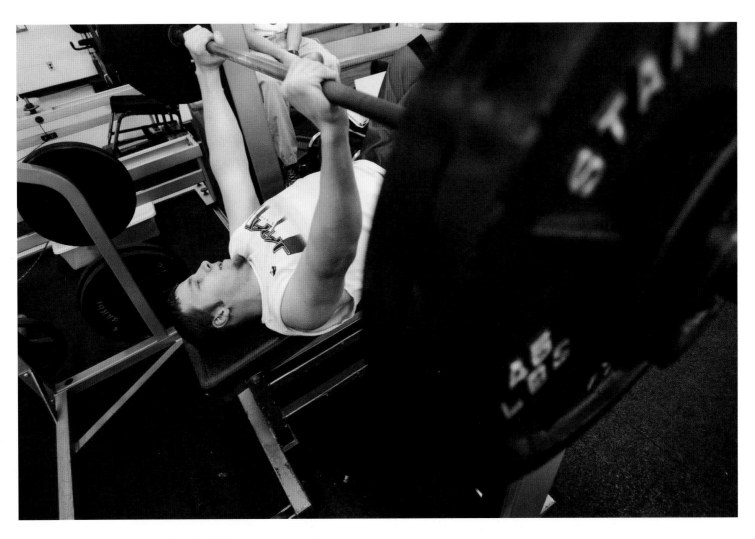

Denny Muha lifts weights at the Disability Resources and
Educational Services (DRES) facility. Players are expected to
weight train outside of practice.

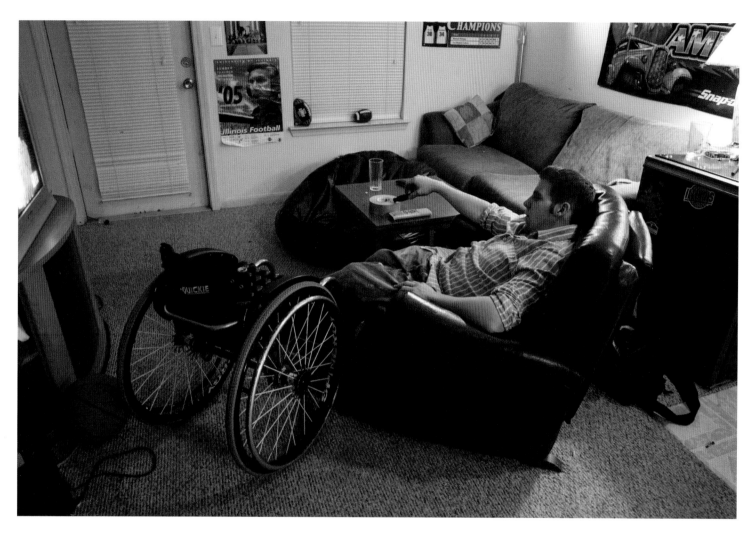

Denny Muha watches television at his apartment after a long day of practice and classes.

"
Wheelchair basketball has gotten me so far, and I've met so many people and done so many things that I wouldn't gain anything from being able to walk. It just isn't worth it.
"

—Denny Muha

Denny Muha lifts his wheel into his car after practice. In order to get into the car, he has to sit in the driver's seat, then dismantle the chair into pieces and put it into the back seat.

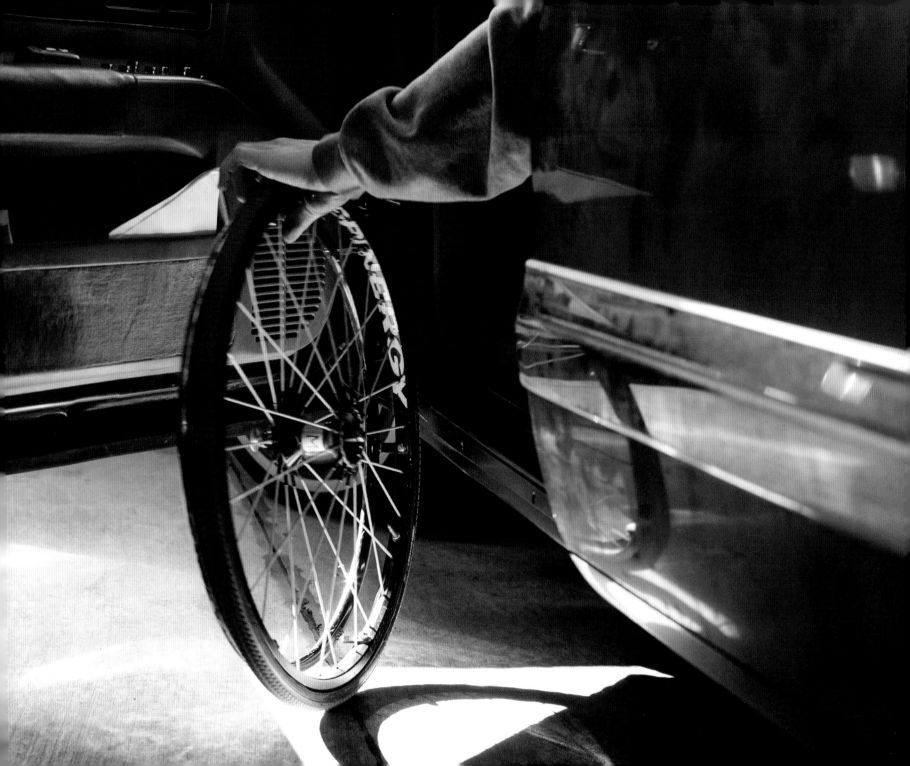

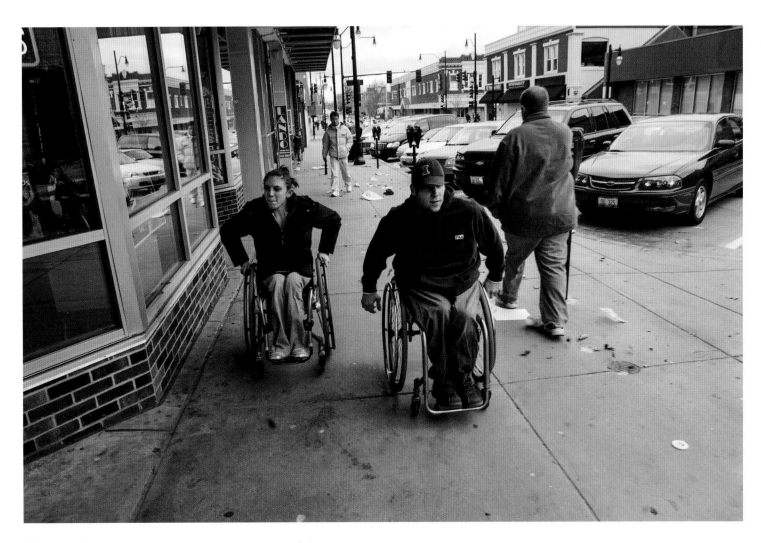

Denny Muha and his girlfriend, Amanda McGrory, roll down
the street back toward their apartment after getting dinner.
McGrory is a member of both the women's wheelchair
basketball and track teams.

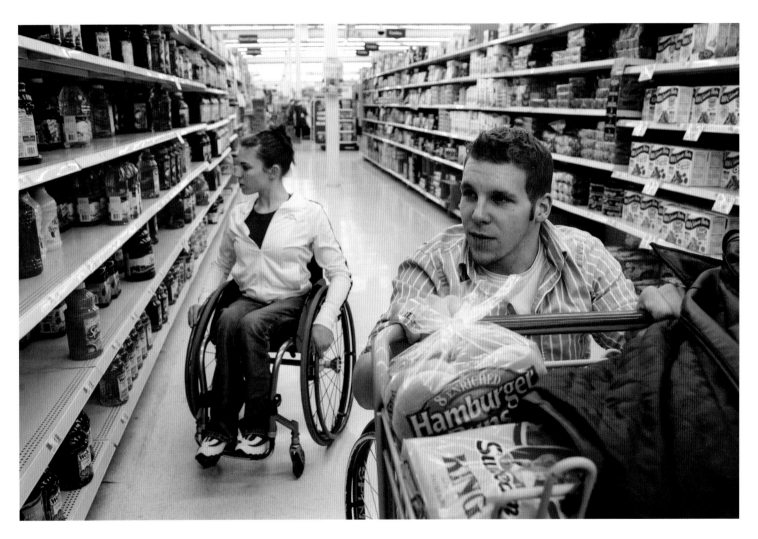

Denny Muha and Amanda McGrory shop for food at Wal-Mart. Given that Denny and Amanda are both in wheelchairs, "it's easier to deal with any disability-related issues," Muha said. "I think it's easier because there's less to explain."

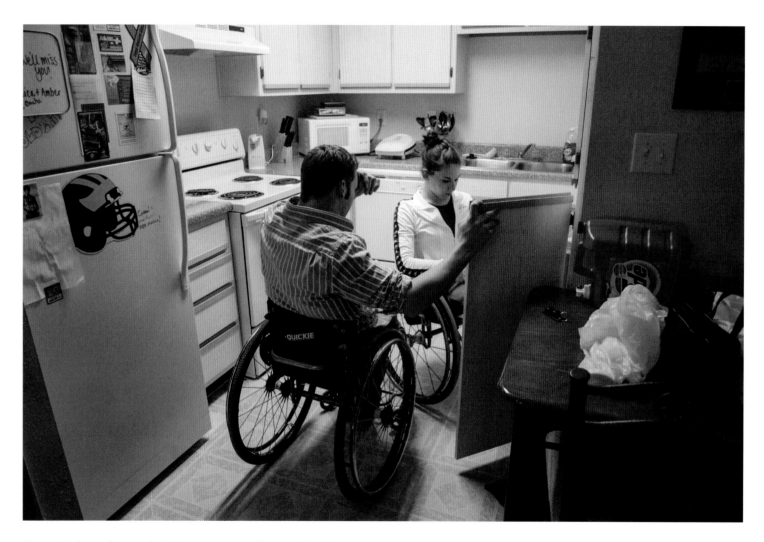

Denny Muha and Amanda McGrory prepare dinner at Muha's apartment after shopping.

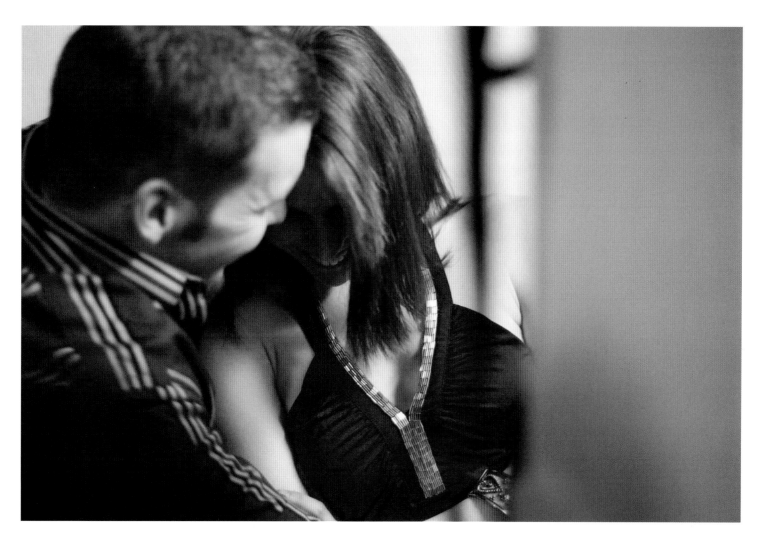

Denny kisses Amanda during a party for team member
Matthew E. Buchi's twenty-first birthday. At this point, they
had been together for a year and a half.

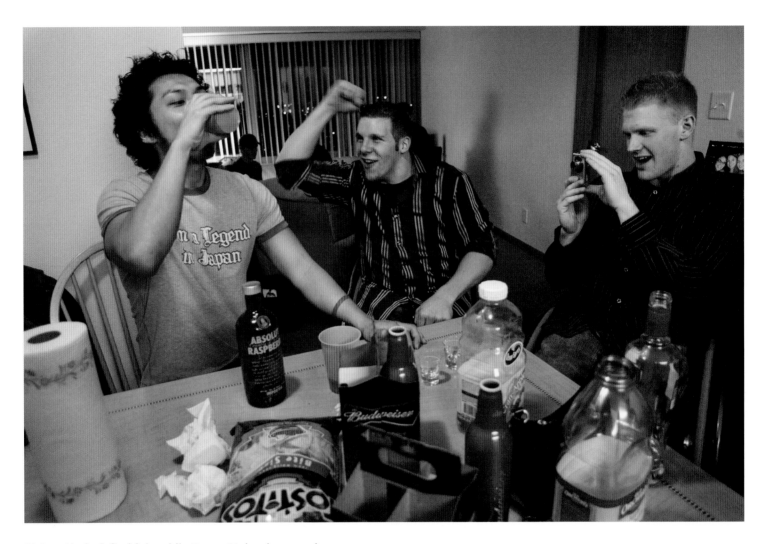

Wataru Horie, left, drinks while Denny Muha cheers and
Matthew E. Buchi takes pictures during a party for Buchi's
twenty-first birthday.

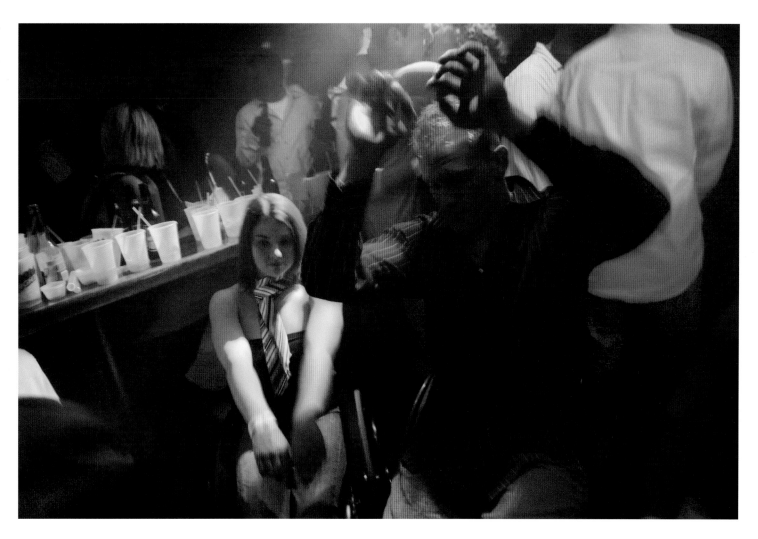

Matthew E. Buchi dances with women's track athlete Jessica Galli at Joe's Brewery in Champaign, Illinois, for a night out to celebrate his twenty-first birthday. Despite the difficulty of getting into crowded bars, they still go.

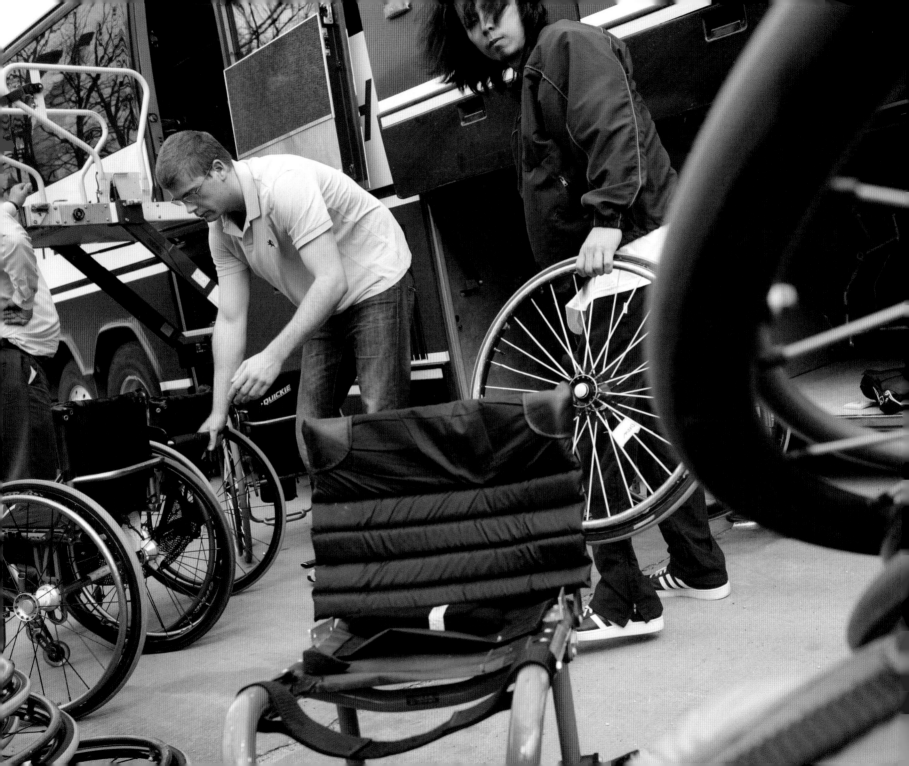

Riding the Bus

"

We have the ADA, so as a student athlete that makes us closer to being your able-bodied student athlete, where all they're worrying about is their school and their sports. When you're in a wheelchair, there's a lot of other stuff on your plate, but thanks to the guys that came before us, they took all that stuff and they handled it.

"

—Denny Muha on the Americans with Disabilities Act

Wataru Horie, center, and Lars Spenger unload the bus after returning from a tournament.

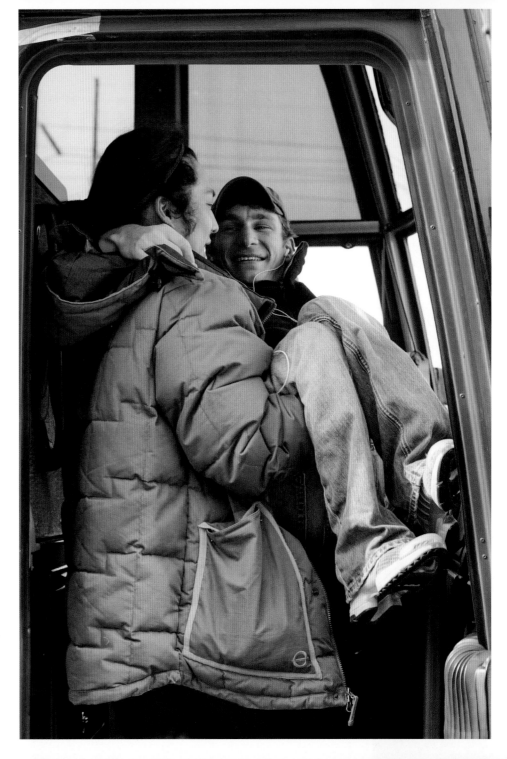

As a friendly way of joking around, Wataru Horie carries Josh George onto the bus after a tournament.

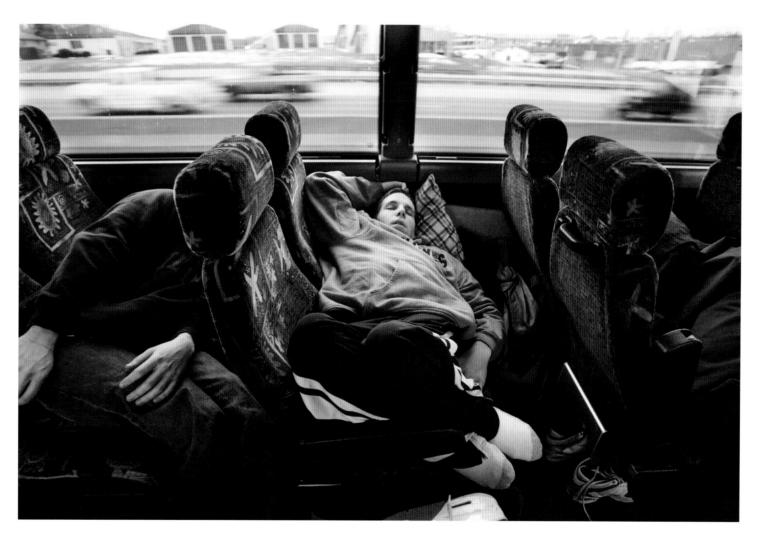

Denny Muha sleeps on the bus ride to a University of
Missouri tournament. During the basketball season the team
has tournaments almost every weekend.

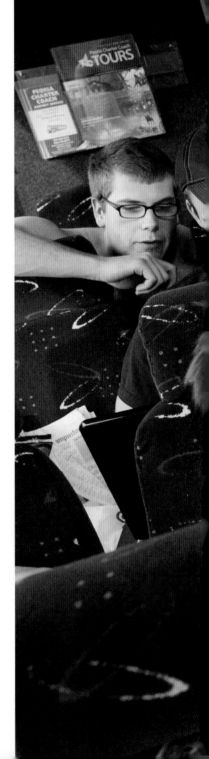

To ward off boredom on a bus trip, from right, Alex Grunstein, Steve Serio, and trainer Karla Wessels play cards; from left, Lars Spenger, Aaron Pike, and Brian Bell watch video on a laptop; and Drew Dokos, in the back, reads.

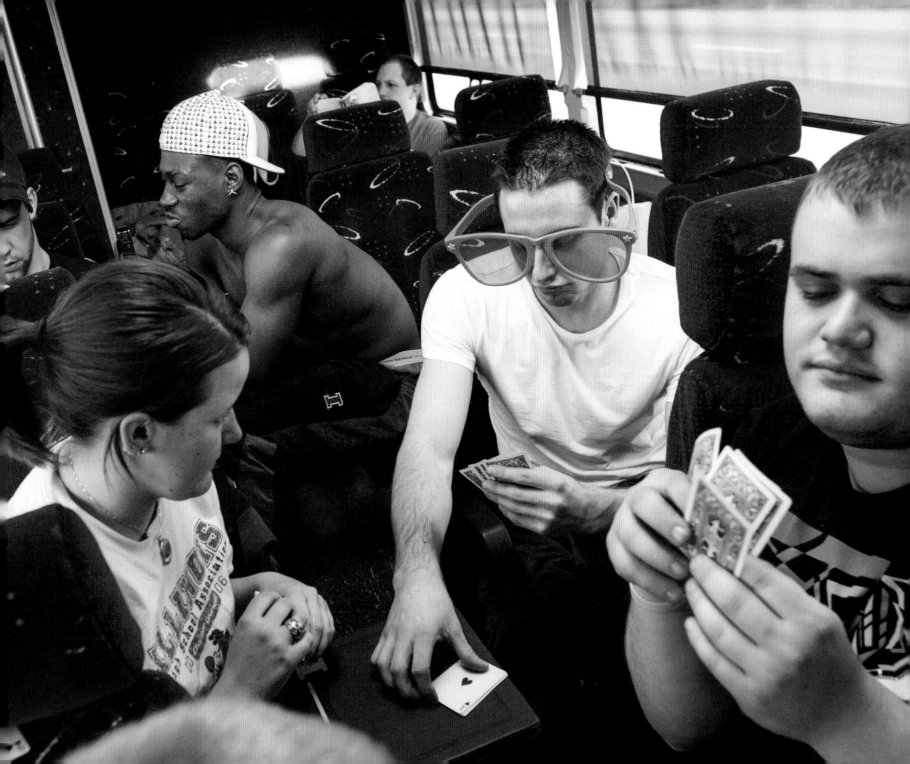

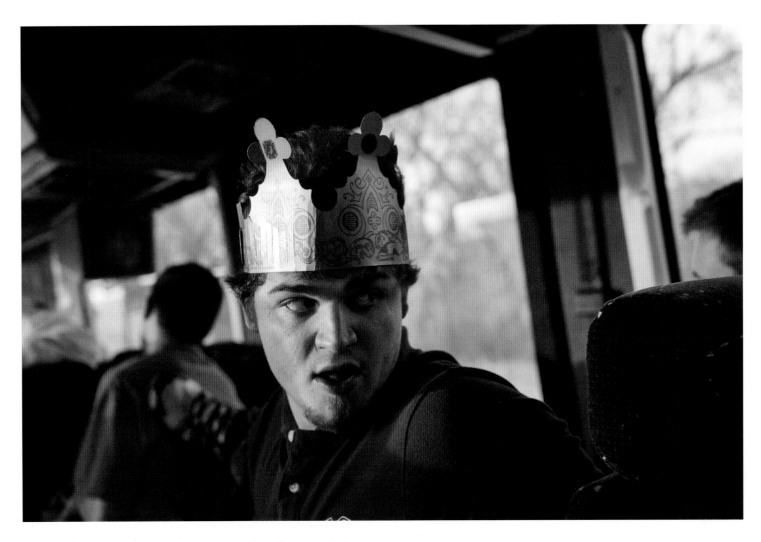

Joey Gugliotta wears a crown from Burger King after a meal at
the fast food chain during an Oklahoma tournament.

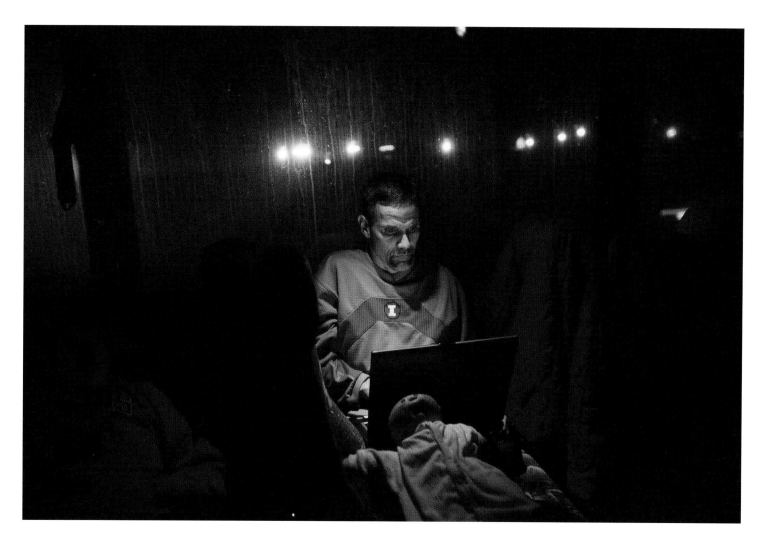

Head coach Mike Frogley edits stats and sends out press
releases from the weekend's tournaments on the late-night bus
ride home from the University of Missouri.

The sun sets as the team returns home from a tournament in Edinboro, Pa., at Edinboro University.

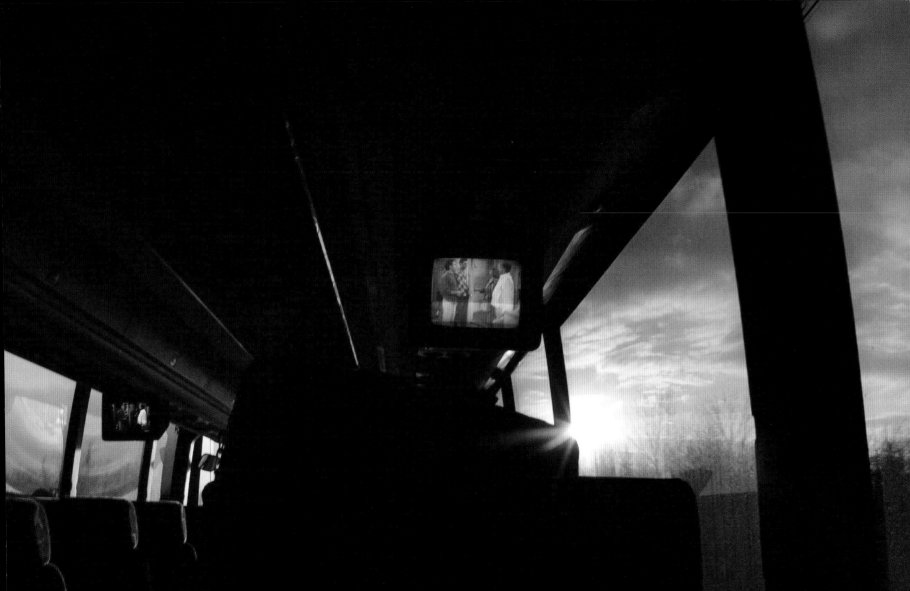

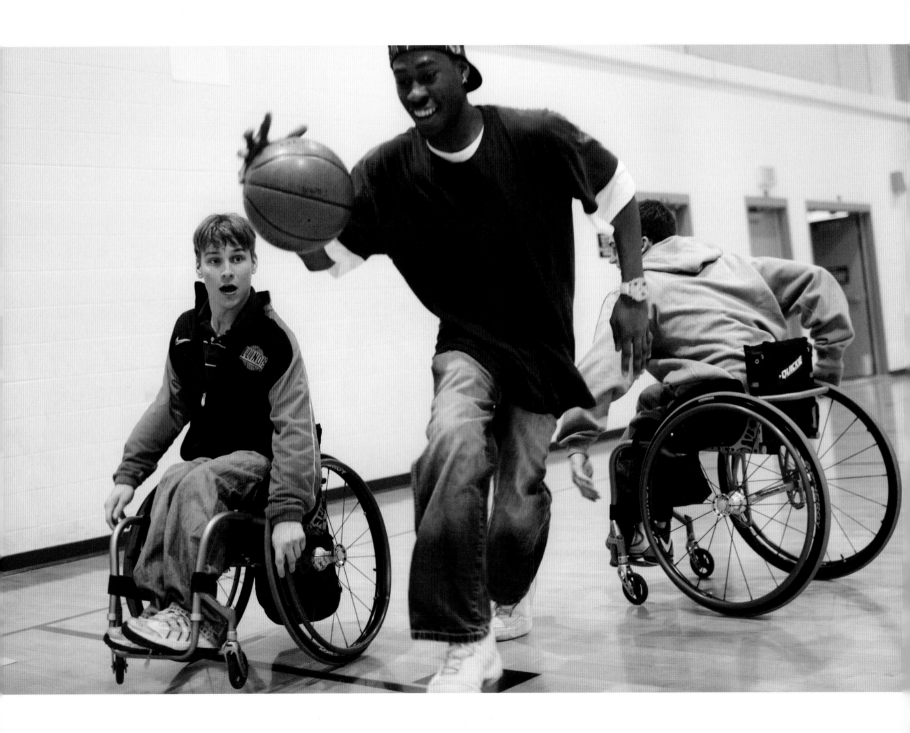

Games

That's the reward of
practicing hard: to
use what you practice
in a game.

—Denny Muha

Brian Bell, center, Ryan Chalmers, left, and Tom Smurr play
basketball between games at a tournament.

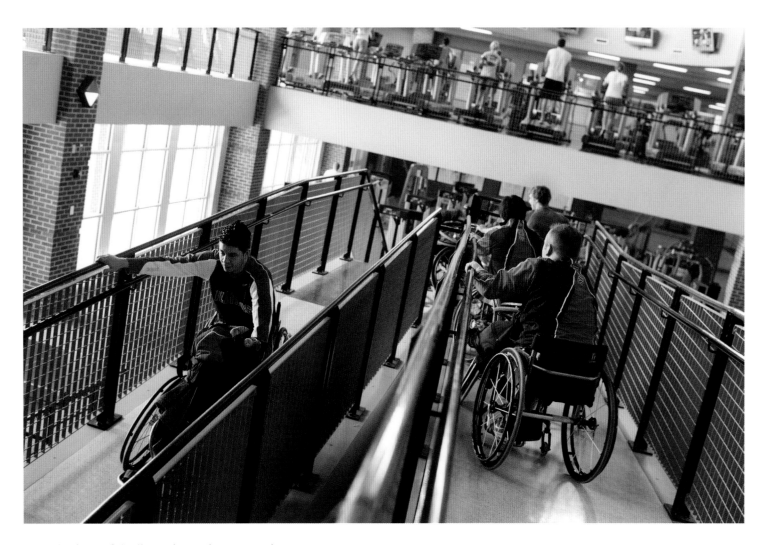

From the front of the line, Jaime Baltazar, Brandon Wagner, Peter Won, and Alex Grunstein wheel their game chairs down ramps to get to a basketball court.

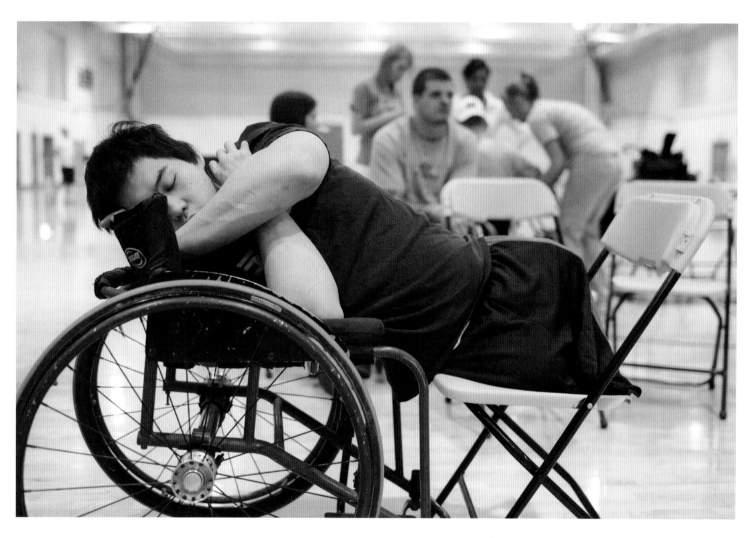

Peter Won rests after the team won a game at a tournament.

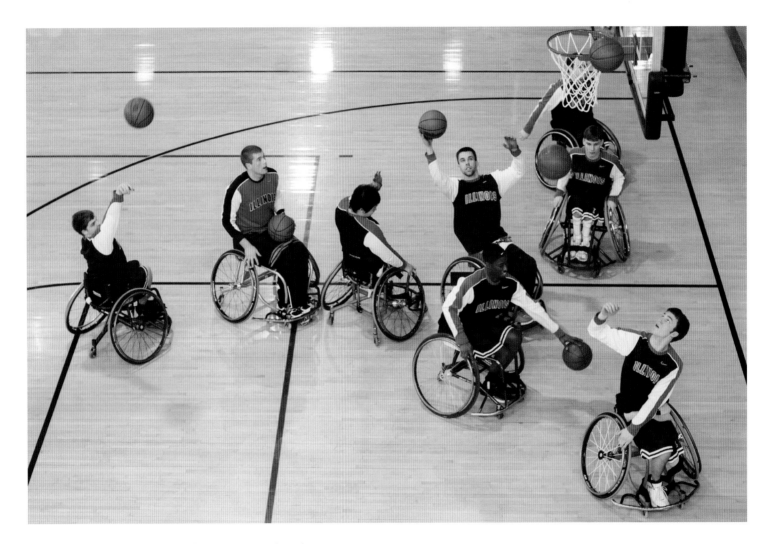

The team practices shooting before a game against the University of Texas–Arlington during a tournament at the University of Missouri. "We have so much talent on this team, now it's just figuring out how to make everyone's talents come together," captain Steve Serio said.

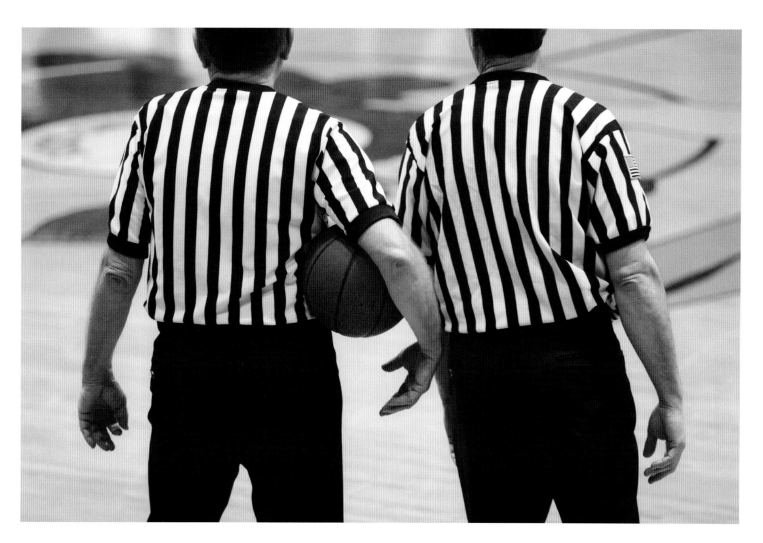

Referees look on during an Illinois vs. Edinboro University game. All games are officiated and subject to rules similar to basketball, with a few exceptions that take into consideration the motion of a wheelchair. An additional player classification system based on level of motion is the most unique rule.

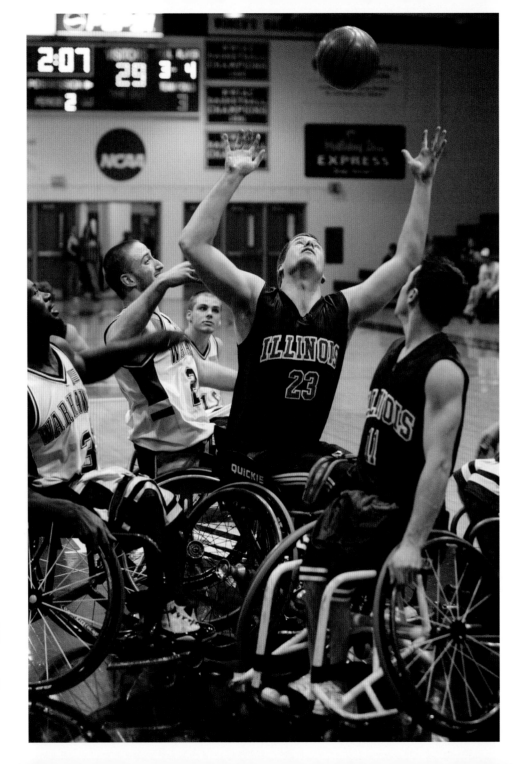

Lars Spenger reaches for the ball against, from left, Wisconsin-Whitewater's Matt Scott, Rob Welty, and Derrick Lee during a game against the University of Wisconsin-Whitewater. "We've always had the mindset that there are two teams out there: us and Whitewater," Aaron Pike said. "We have to be the team to beat them."

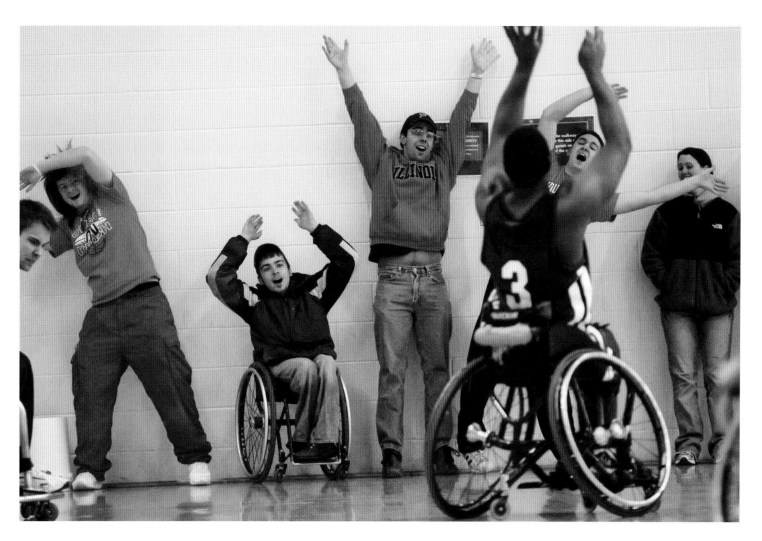

From left, Brian White, wheelchair basketball player Cully Mason, Joey Sula, and Dan Brencic try to distract Wisconsin-Whitewater player Matt Scott during a game against Illinois.

Paul Ward maintains possession during a game against the Rehabilitation Institute of Chicago (RIC) in a home tournament. Illinois won, 82–42.

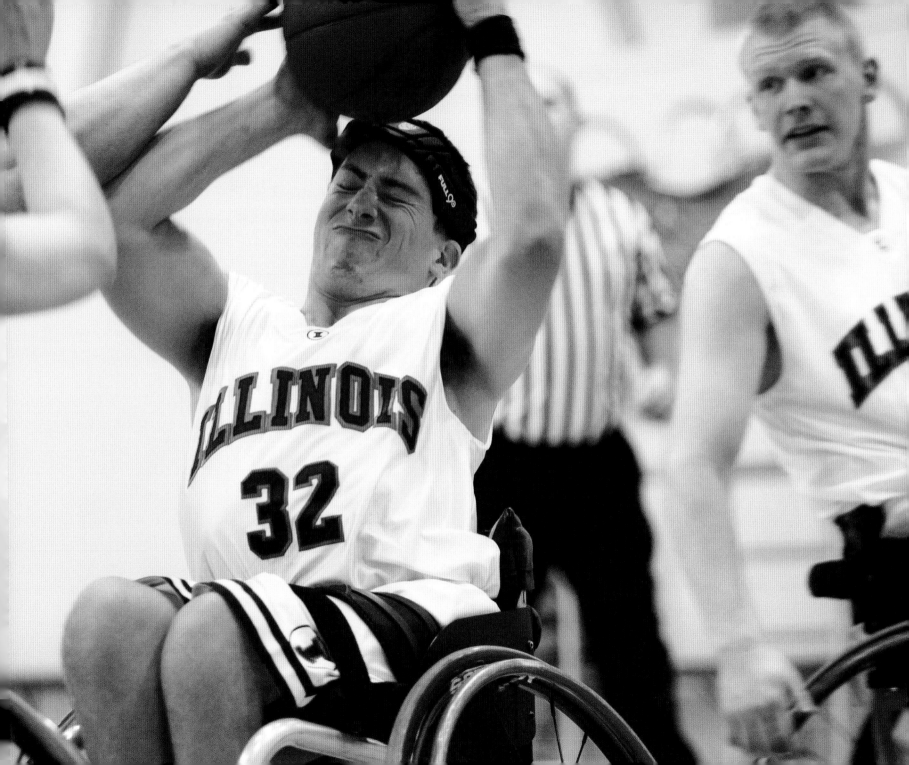

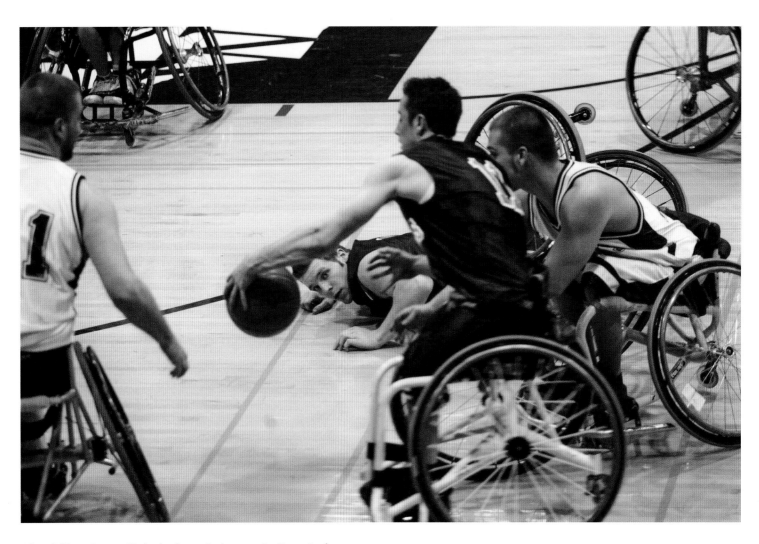

After falling, Denny Muha looks up to teammate Steve Serio carrying the ball down the court during a game against their chief rival, the University of Wisconsin-Whitewater. "I always like to put together the toughest schedule I possibly can," head coach Mike Frogley said. "If you want to be a great team, you have to play great teams and you can't shy away from the competition."

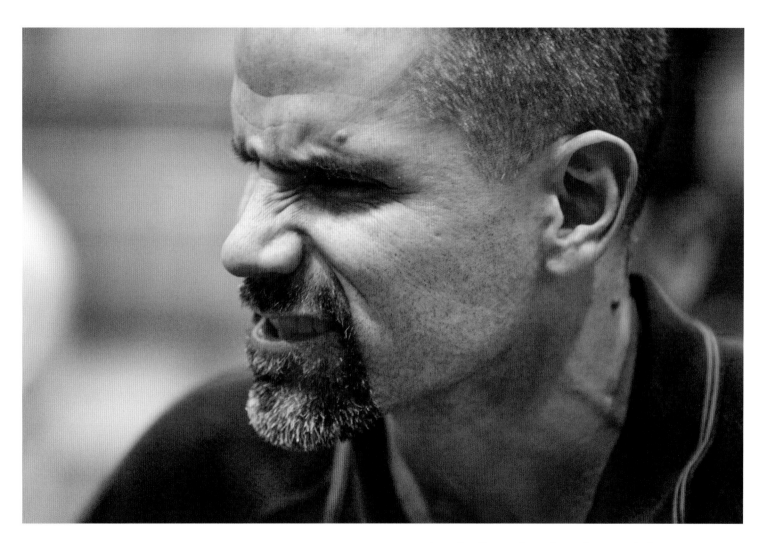

Head coach Mike Frogley talks to the team during a game against Wisconsin-Whitewater. "Let's show 'em that, you know what, they bleed like everyone else," Frogley said emphatically. Illinois lost to Whitewater, 45–52.

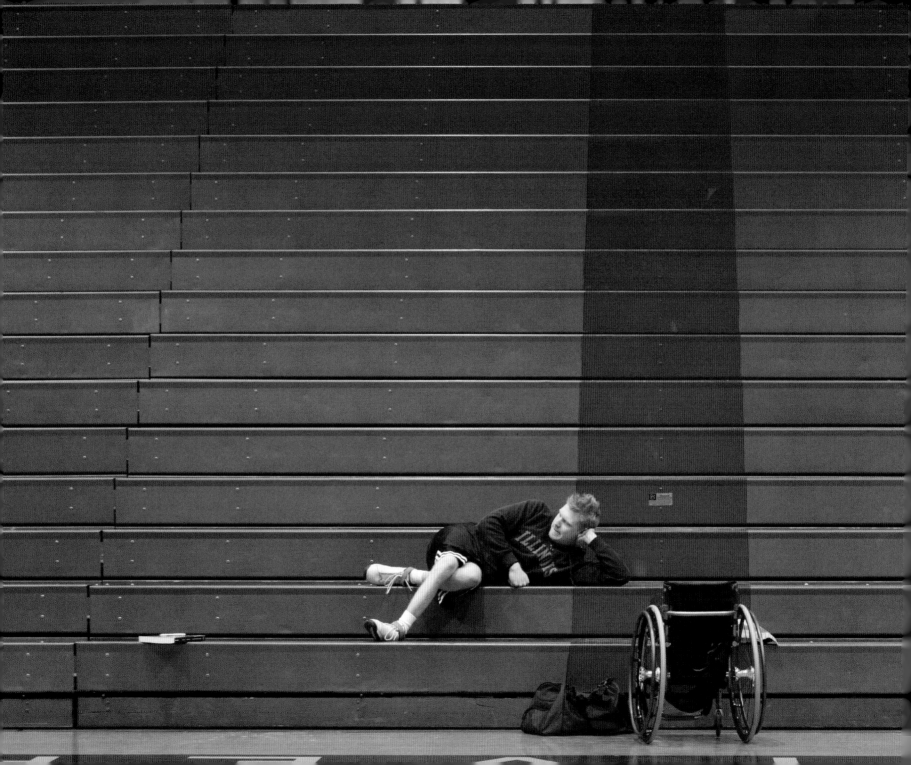

Matthew E. Buchi watches the women's wheelchair basketball team play during a tournament at Edinboro University.

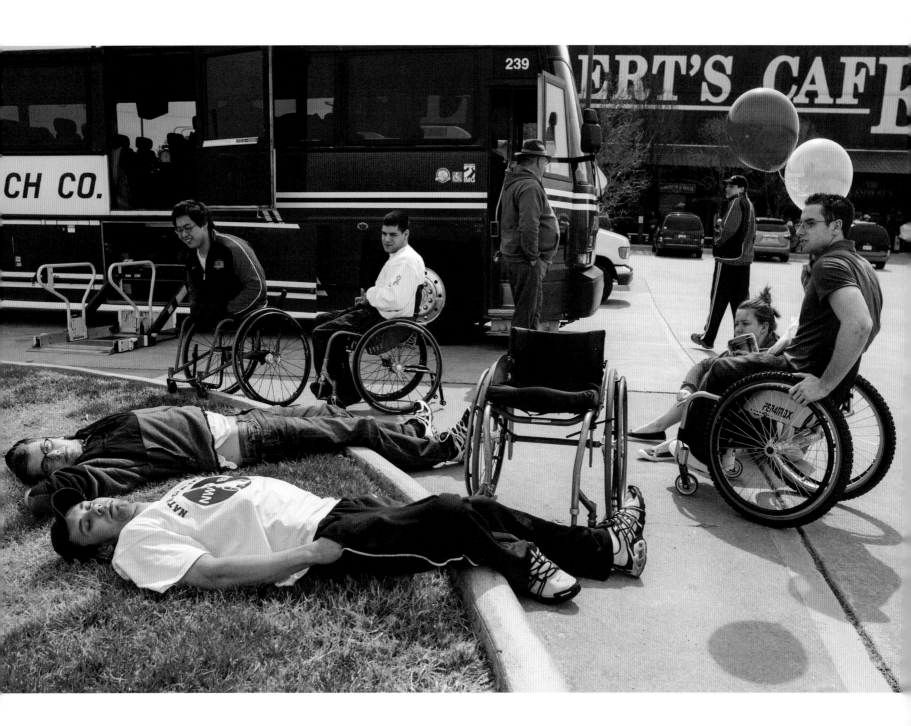

On the Road

We're like one big family: we laugh, we joke, and we have a good time.

—Joey Gugliotta

The team stops for food and rest at Lambert's Cafe in Ozark, Mo., on the road back from an Oklahoma tournament.

Snow covers the ground for some of the winter tournaments,
which presents an additional challenge.

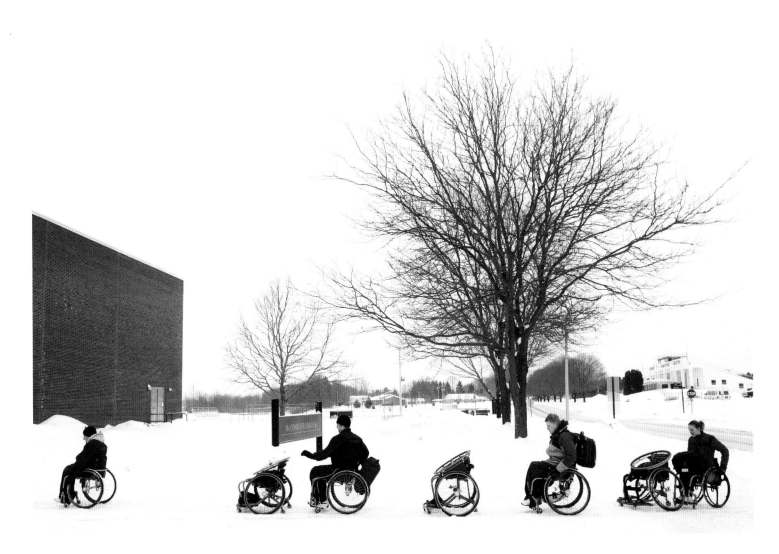

From left, Paul Ward, Brandon Wagner, Matthew E. Buchi, and women's team member Edina Mueller push their game chairs through the snow on their way to a tournament at Edinboro. Each athlete typically carries two chairs and spare wheels with them to every tournament. They don't have much traction on the uneven, snowy surface.

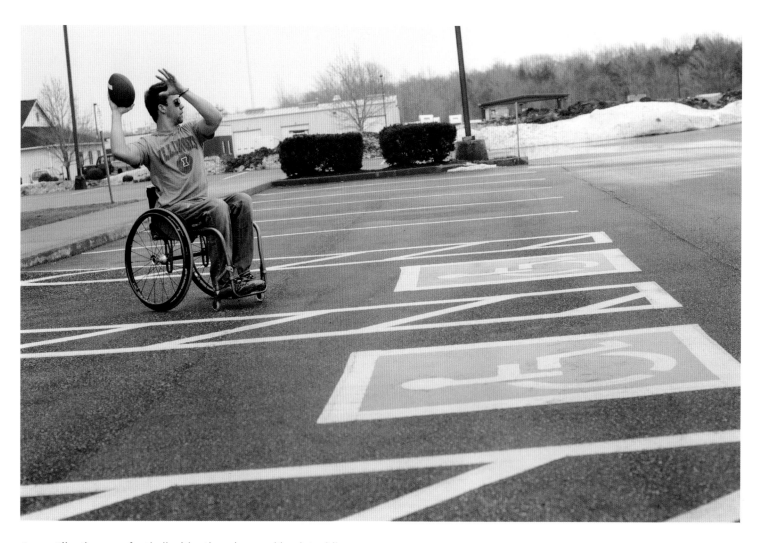

Aaron Pike throws a football with others in a parking lot while
waiting to load up on the bus.

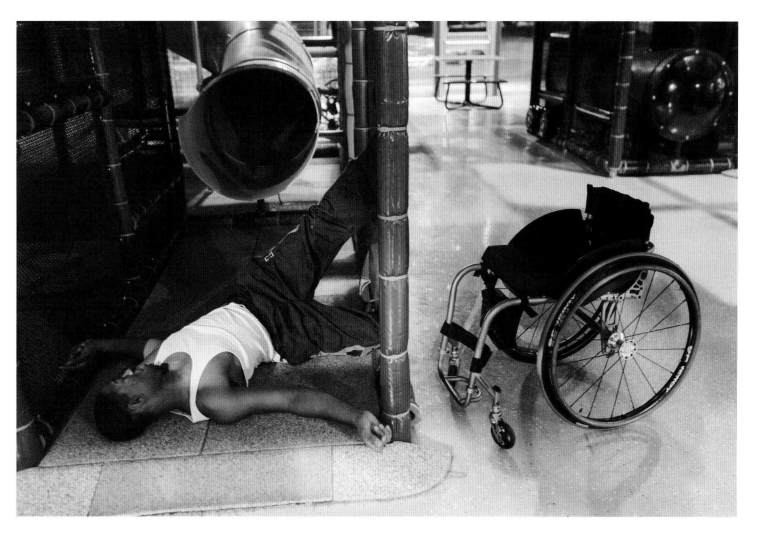

Brian Bell rests after coming out of the play pen at a Burger King adjacent to the hotel where he was staying. Bell and a few other players decided they wanted to play there after competing in three games that day. "I felt like a kid again!" exclaimed Joey Gugliotta after they played tag for an hour.

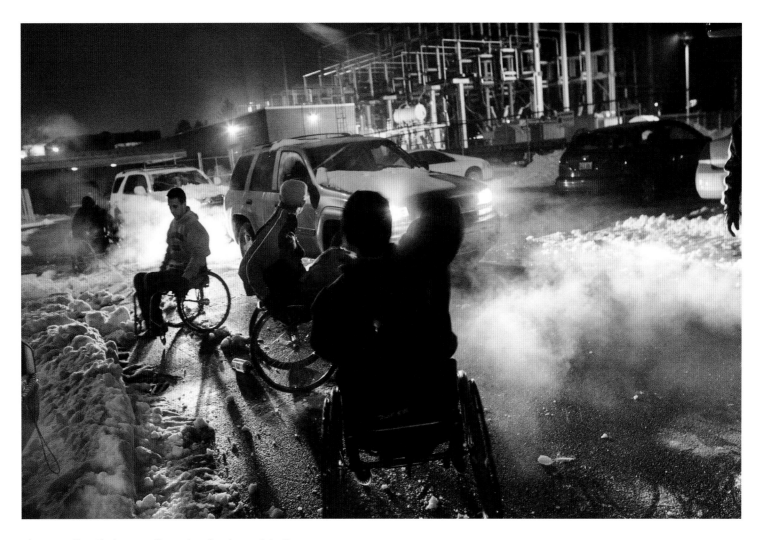

Players roll to their cars after returning home late from a
University of Missouri tournament.

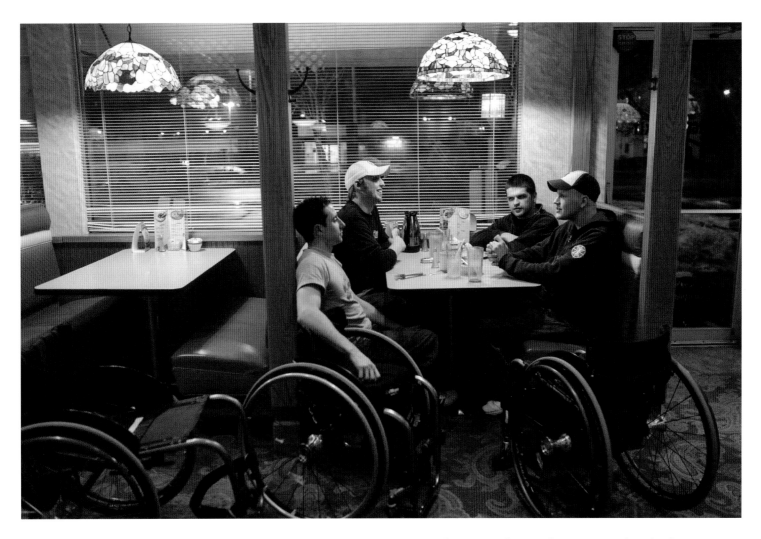

From left, Steve Serio, Brandon Wagner, Brian Sheehan, and Matthew E. Buchi eat dinner together at Perkins Family Restaurant after an Edinboro tournament.

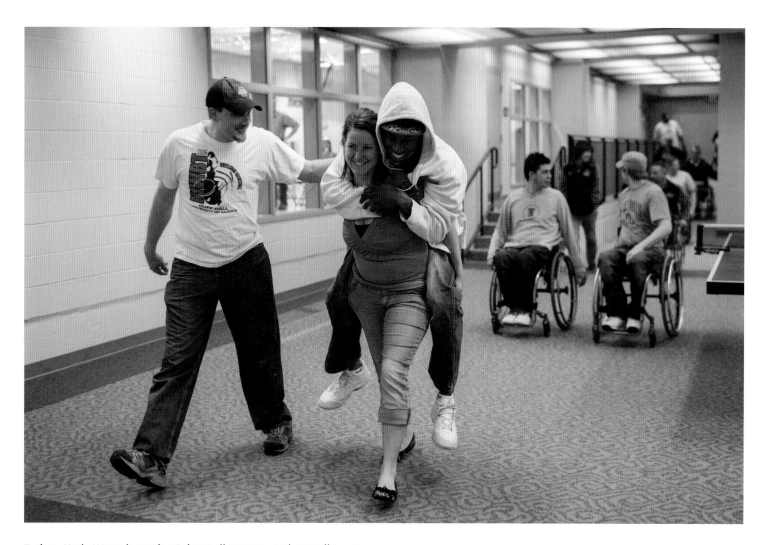

Trainer Karla Wessels carries Brian Bell as Drew Dokos walks
beside them on the way back to the hotel after tournament play.

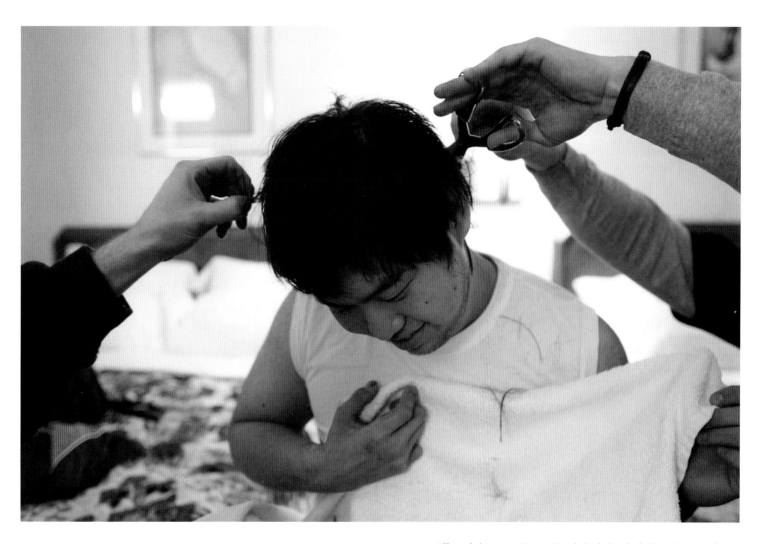

Aaron Pike, right, cuts Peter Won's hair in their hotel room the night before they played their first game in a championship tournament. "I'm donating hair to championship," Won said.

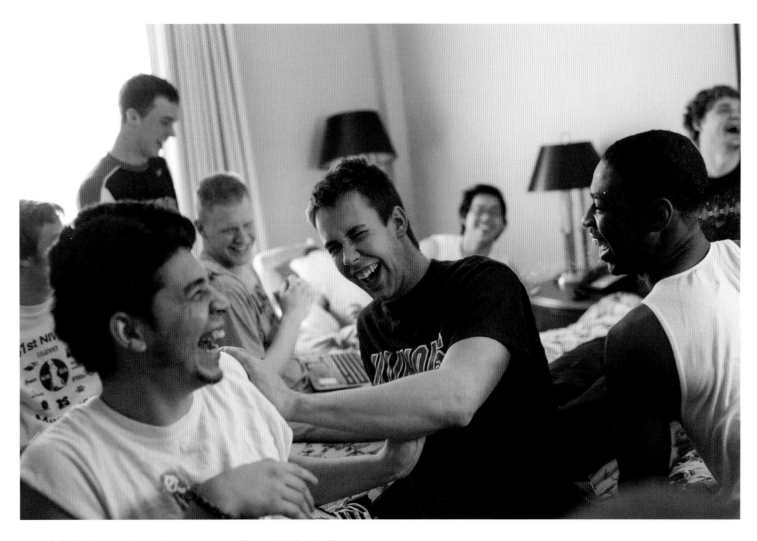

From left, in front, Jaime Baltazar, Aaron Pike, and Brian Bell laugh together with teammates during a team meeting at their hotel. "Off the court, they really interact with each other really well," head coach Mike Frogley said. "And that's good—in the long run, that'll help them on the court."

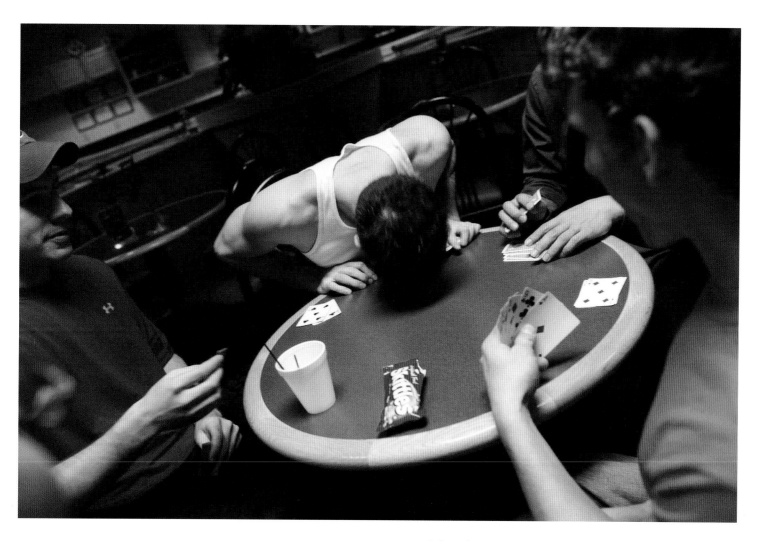

From left, trainer Zach Stutzman, Steve Serio, and Josh George play a game of euchre after a tournament had ended. They stayed up all night because their bus departed at 5:00 A.M. the next morning.

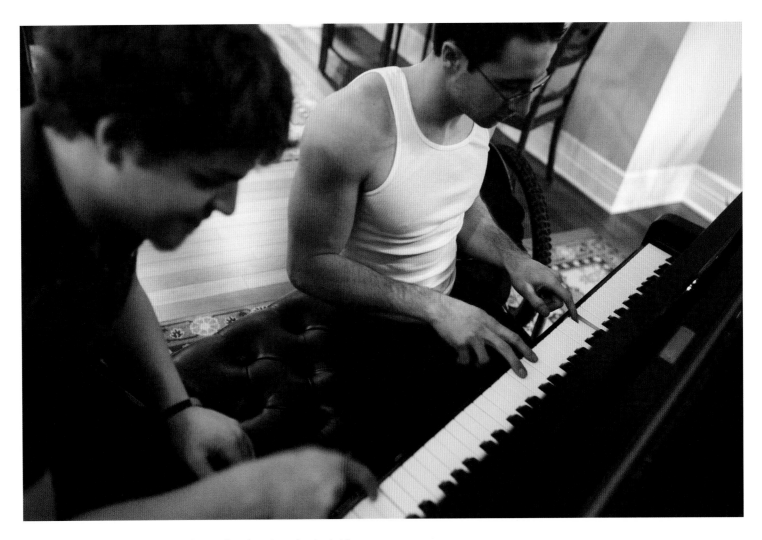

Steve Serio, right, and Joey Gugliotta play the piano in the lobby
of their hotel.

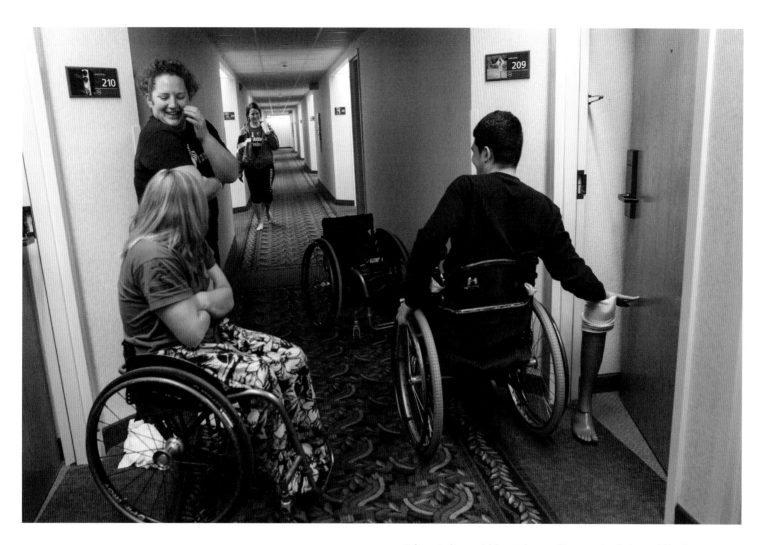

Jaime Baltazar hides Brian Bell's prosthetic leg while, from right, trainers Karla Wessels and Jennifer Brown, and women's team member Shelley Chaplin, observe at their hotel. Players frequently play jokes on one another.

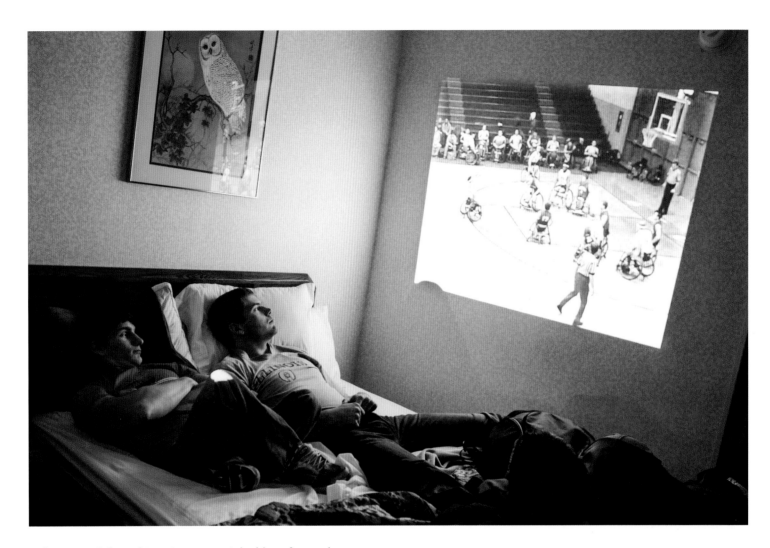

Josh George, left, and Lars Spenger watch video of a previous game against Edinboro University in head coach Mike Frogley's hotel room. They regularly study past games to learn from their opponents, study mistakes, and improve their playing abilities.

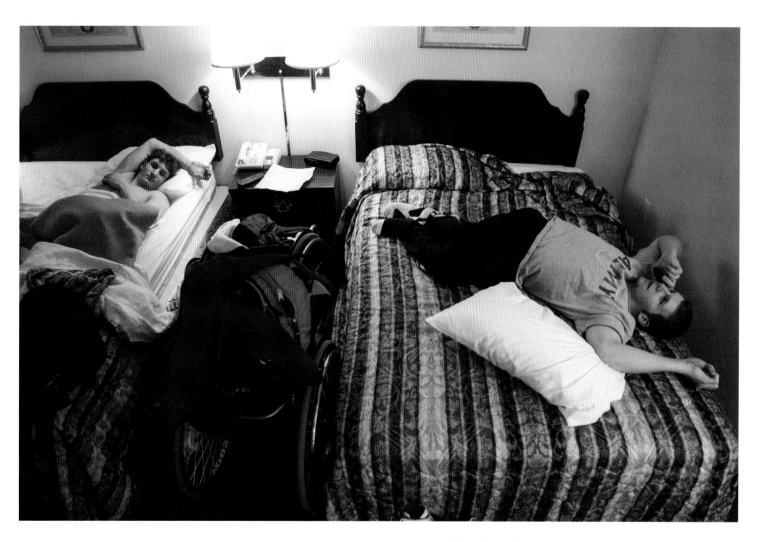

Denny Muha talks on the phone with his girlfriend, Amanda McGrory, as Josh George falls asleep in their hotel room.

Steve Serio fixes his hair while sitting atop a counter at his hotel after a wheelchair basketball tournament.

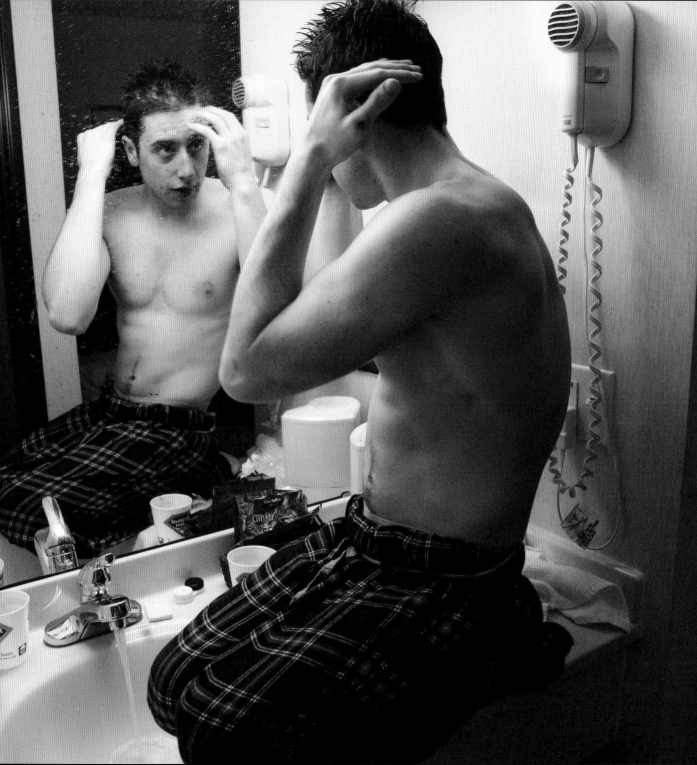

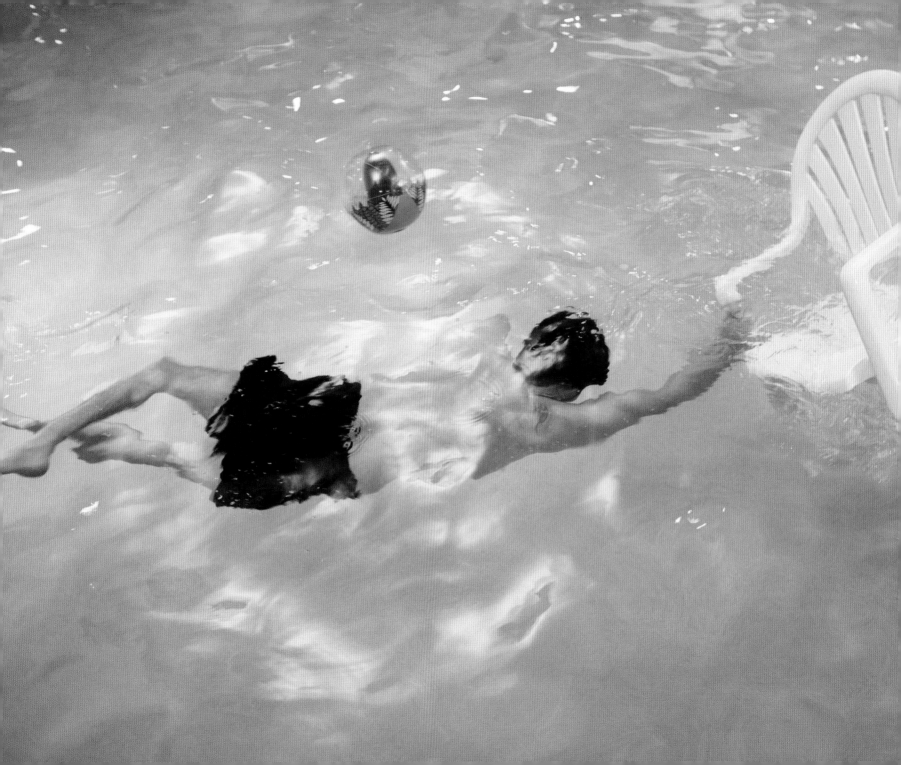

Since he couldn't jump into the pool on his own accord due to paralysis below the waist, player Joey Gugliotta tried falling in the pool at his hotel while sitting in a chair. "I've never jumped into a pool before," Gugliotta said. He also tried setting himself up on a table, while friends Brian Bell and Tom Smurr held it down, so he could fall into the water.

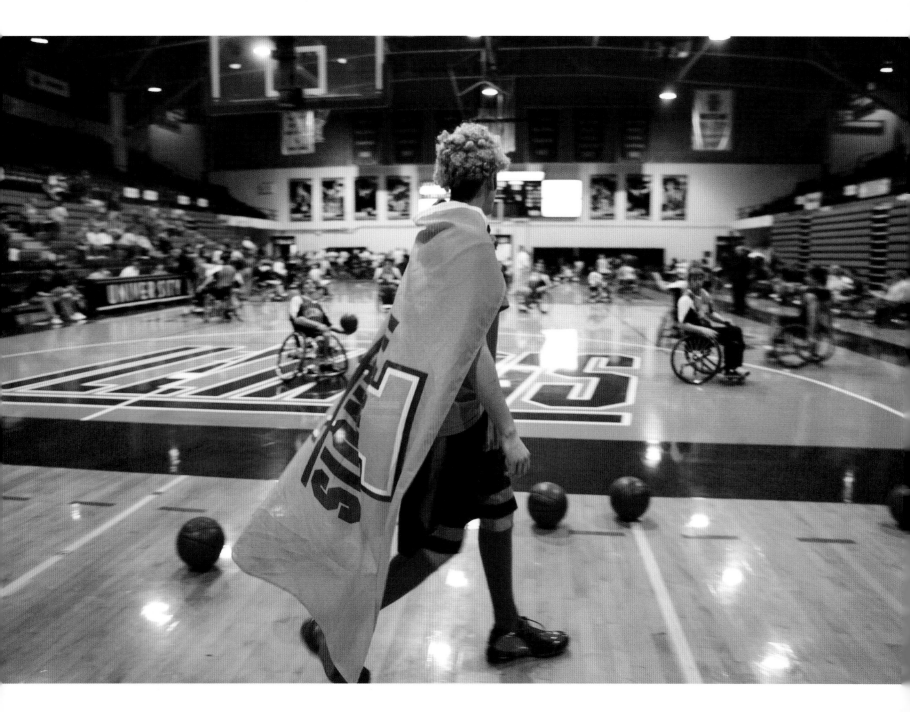

Falling Short

"

You need to lose to really appreciate how hard we work throughout the year. We hit a low point.

"

—Steve Serio

Bryan Itzkowitz supports the Illini during a championship match at Huff Hall in Champaign, Illinois, on March 31, 2006.

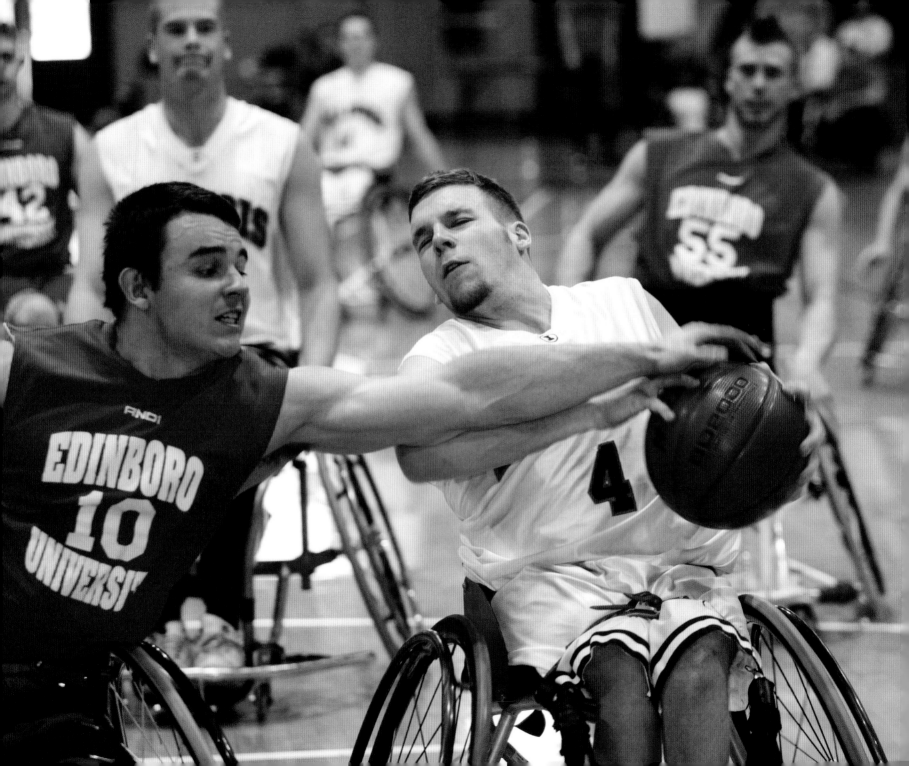

Illinois's Denny Muha attempts to keep the ball away from Edinboro's Jose Leep during the 2006 National Intercollegiate Wheelchair Basketball Tournament (NIWBT). Illinois beat Edinboro in this match, 65–54, but placed third overall.

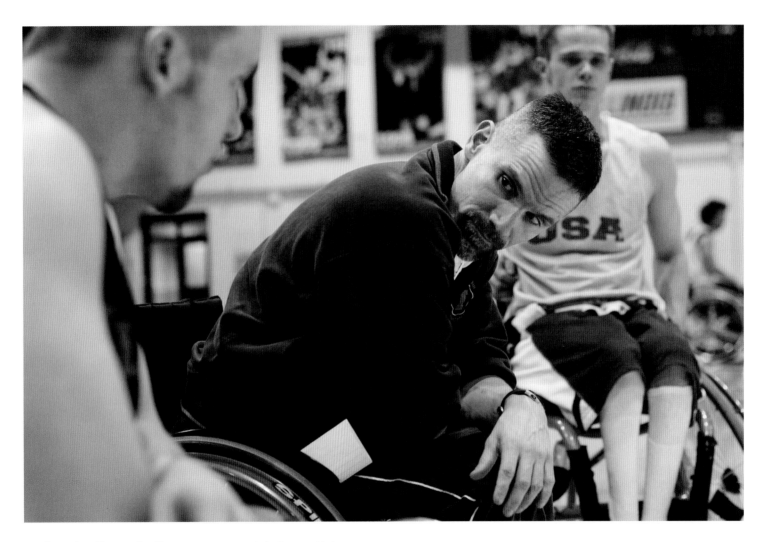

Head coach Mike Frogley listens to team captain Denny Muha
with Jeff Townsend, right, during the 2006 NIWBT.

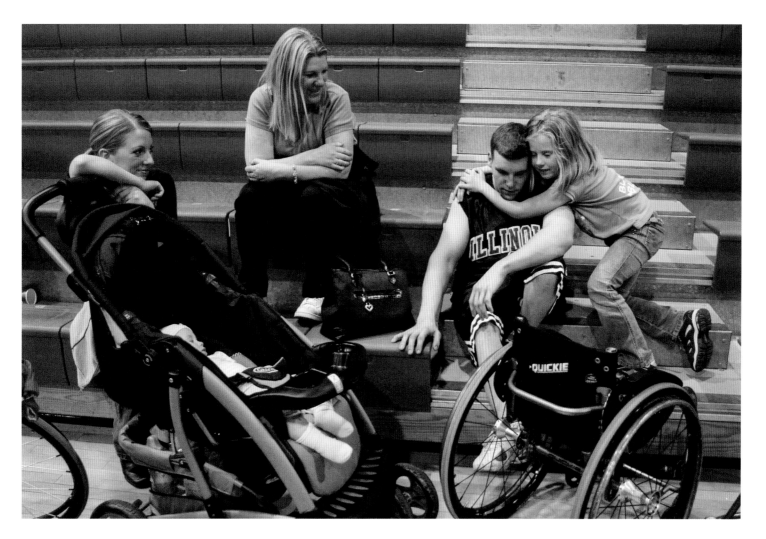

Denny Muha's niece Kyleigh Szamiel hugs him after the team lost in a 2006 semifinal match to Wisconsin-Whitewater, 45–52, as his mother, Linda Muha, center, and sister, Stacie Szamiel, watch. "It hurts, and I feel it right now; I feel Denny," head coach Mike Frogley said after the loss. In the stroller is Denny's one-year-old niece, Tessa Szamiel.

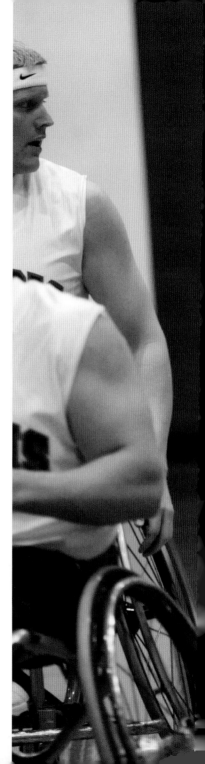

"
Very simply put, gentlemen, that was the worst loss ever against a lower-ranked team by far.
"

—Mike Frogley, head coach

Steve Serio yells down the court to his team during a semifinal game of the 2007 NIWBT. Ten minutes into the game, the number-two Illini were dominating number-three Edinboro, 23–9. As if the switch went off, however, the Illini faltered and lost 58–41.

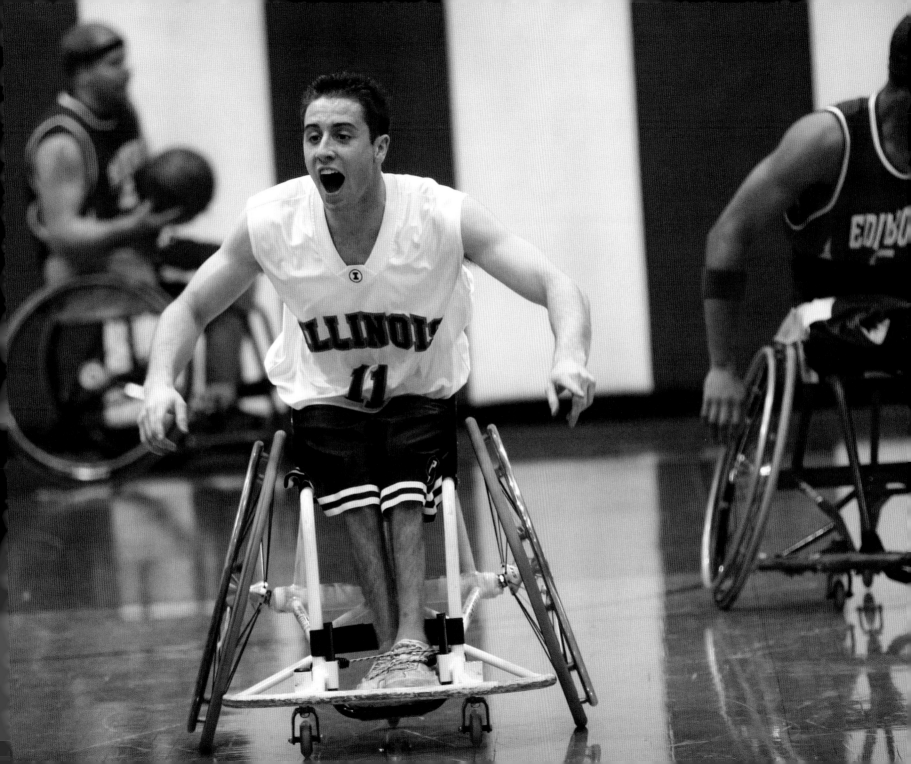

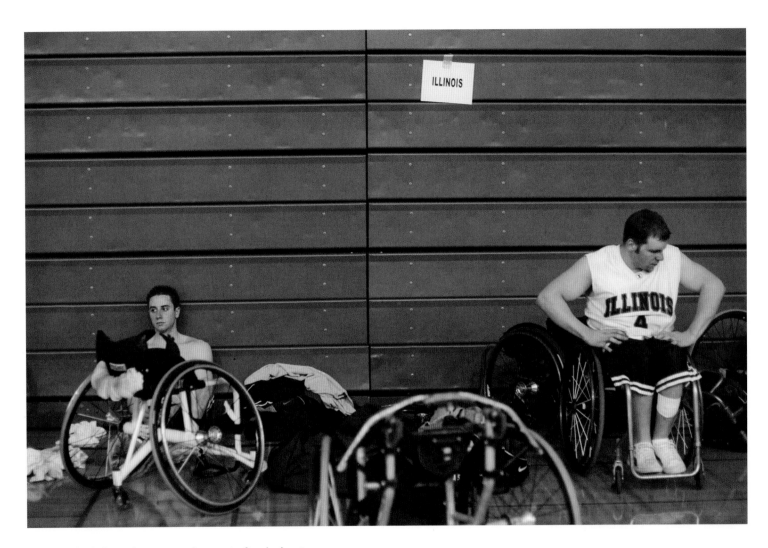

Steve Serio, left, and Denny Muha react after losing to
Southwest Minnesota State, 59–56, in their next match, placing
them at a disappointing fourth in the 2007 NIWBT. "This
weekend, to say the least, was very disappointing," Brandon
Wagner said. "We put in a lot of time and work and made a lot
of sacrifices, and to come away with fourth—it sucks."

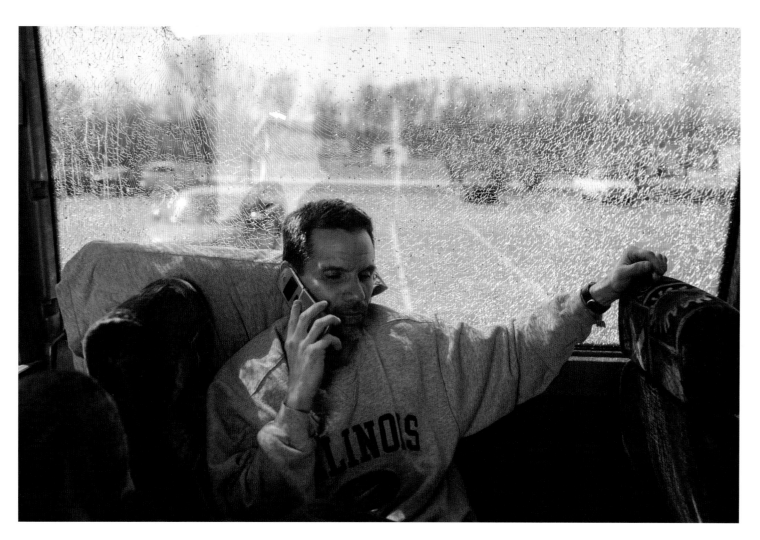

Head coach Mike Frogley phones his wife on the way back from the 2007 NIWBT.

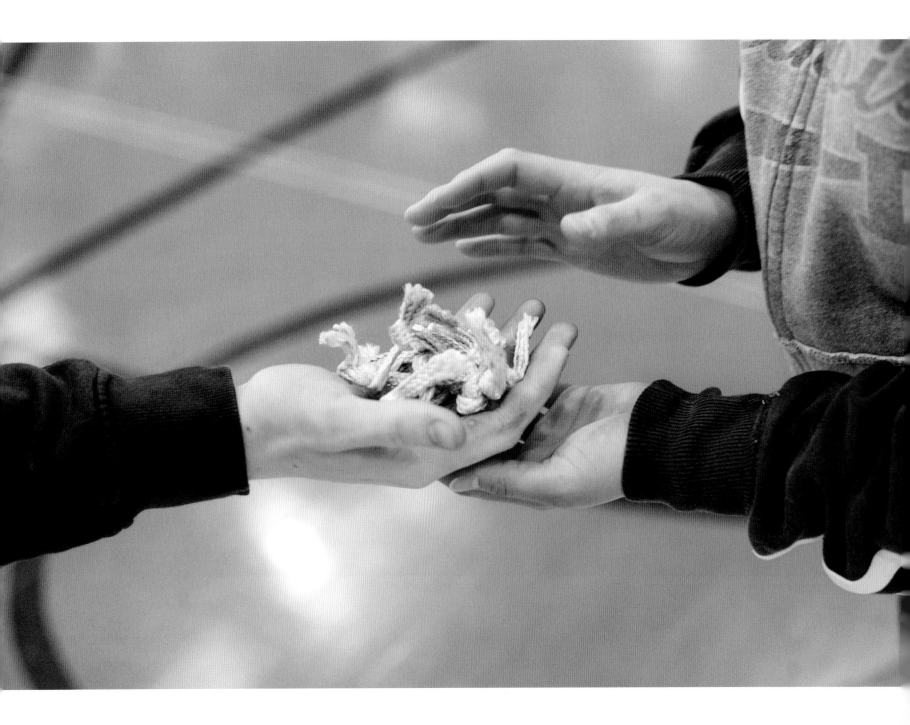

Women's Win

"

It's always fun to play against the ladies. We're a team—we're separate teams but we're the same team, so we're all working toward the same goals: we want to win national championships, bring them to Illinois.

"

—Drew Dokos

The women's team brings back pieces of their net for the men's team after the women won their national championship.

Illinois men's wheelchair basketball players Tom Smurr, center, and Ryan Chalmers, enter Huff Hall in Champaign, Illinois, to cheer for the women's team in the 2008 National Women's Wheelchair Basketball Tournament (NWWBT).

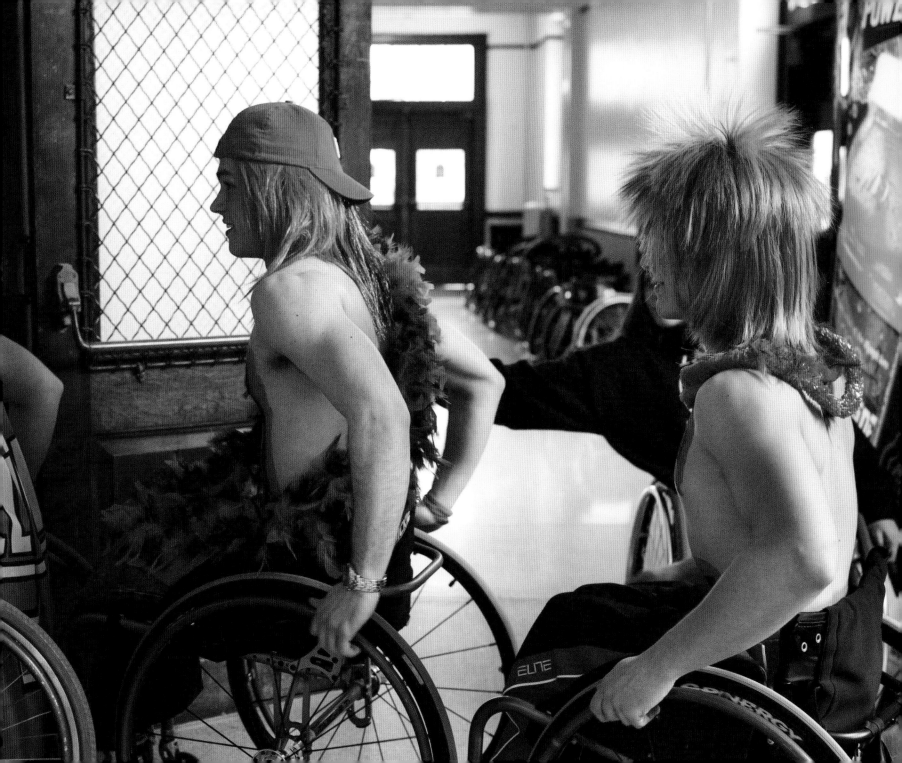

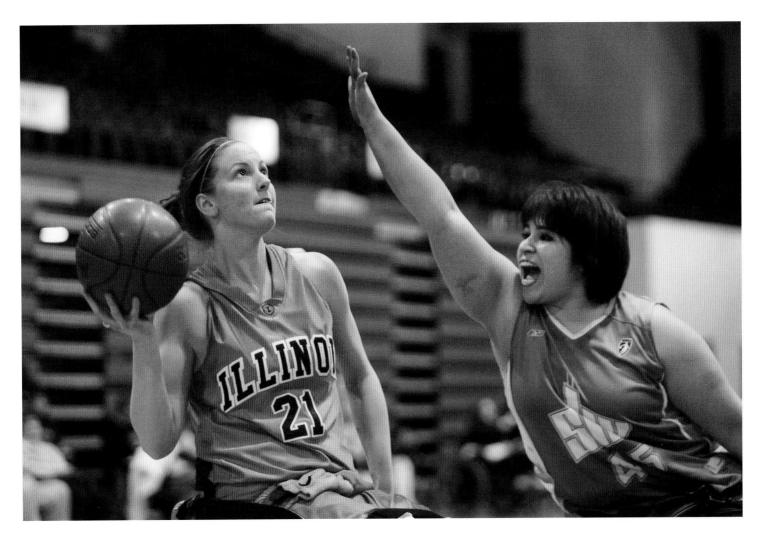

Carlee Hoffman shoots past Rehabilitation Institute of Chicago (RIC) Sky's Gina Wehling during a preliminary match of the 2008 NWWBT. The women beat the RIC Sky, 44–26 to move on to a semifinal game.

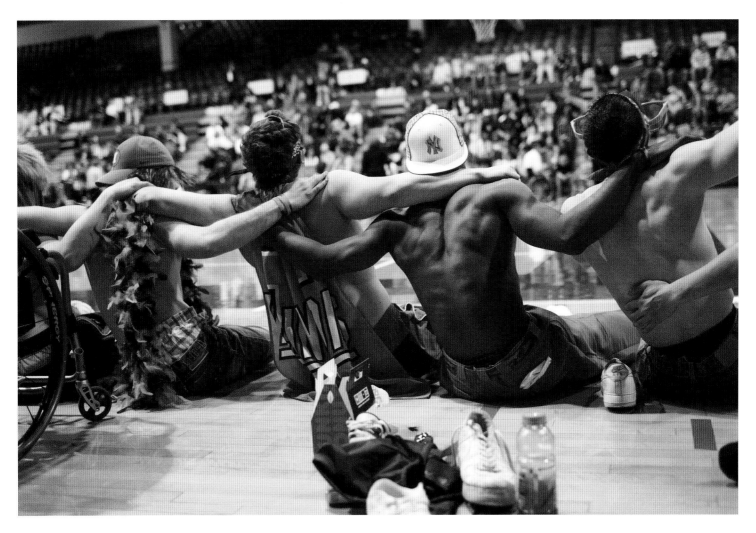

Illinois men's wheelchair basketball players, from left, Tom Smurr, Joey Gugliotta, Brian Bell, and Steve Serio, cheer for the women's team during a match against Alabama at the 2008 NWWBT.

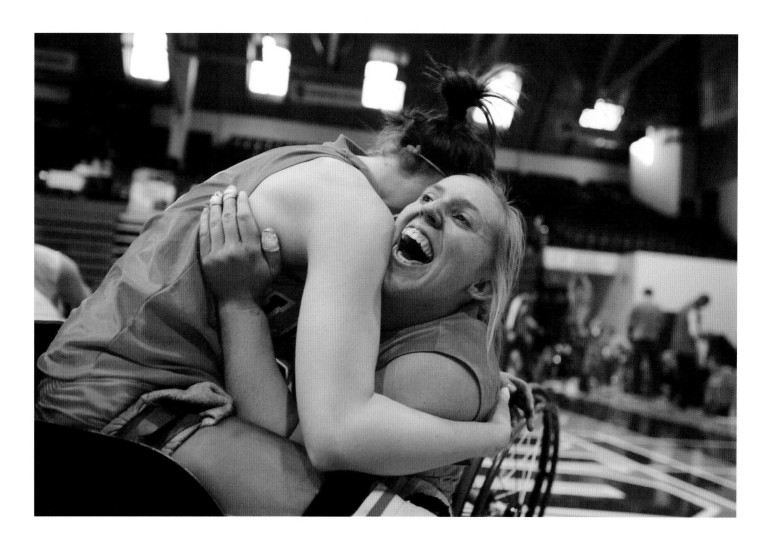

Illinois wheelchair basketball player Shelley Chaplin, right, hugs
teammate Carlee Hoffman after Illinois defeated Alabama,
44–43, to win the NWWBT on March 1, 2008. "We did it! We did
it!" screamed team captain Hoffman. "It's finally over!" Chaplin
was named the tournament MVP.

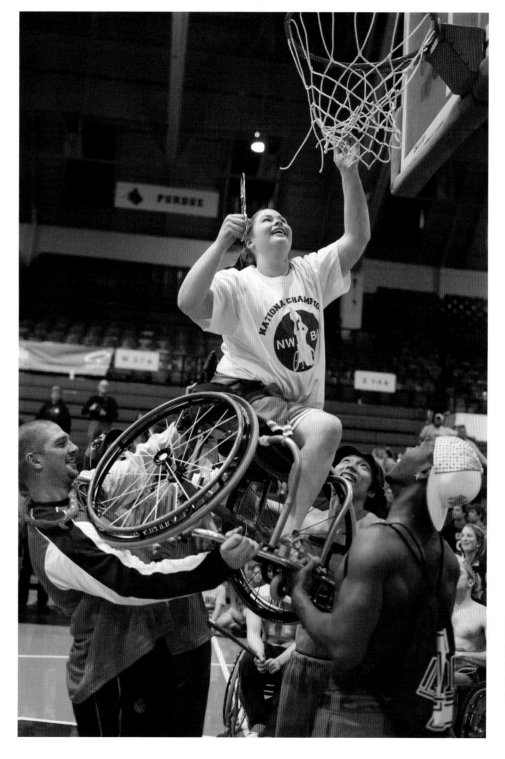

From left, men's wheelchair basketball players Adam Lancia, Wataru Horie, and Brian Bell lift women's player Shawna Culp to the basket after the women won the 2008 NWWBT. The team had taken the title for the last three years in a row and for the sixth time in seven years.

The Championship

"

If they're not willing to do the work, then we shouldn't win a championship; we shouldn't be given it. It should be something that you earn, and it should be difficult to achieve. You should have to sacrifice.

"

—Mike Frogley, head coach

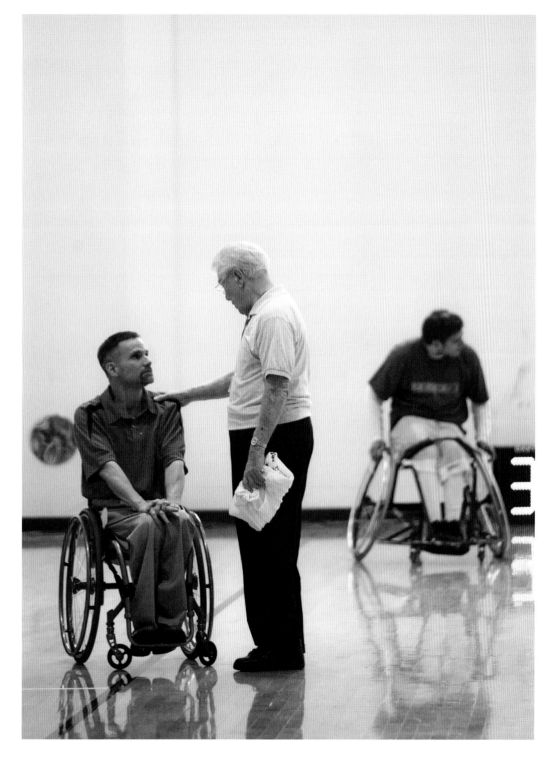

Dr. Tim Nugent talks to head coach Mike Frogley before the 2008 NIWBT. Dr. Nugent created collegiate wheelchair basketball in the United States with the first team, the University of Illinois Gizz Kids, in 1948.

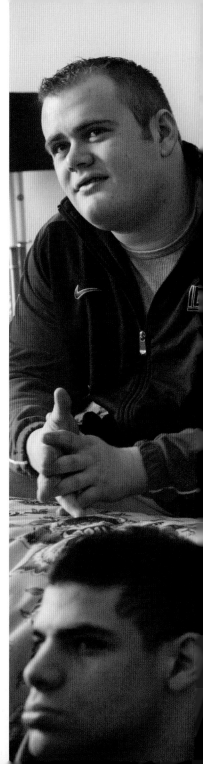

Players listen to head coach Mike Frogley and watch video during a team meeting at the hotel before their first match of the NIWBT.

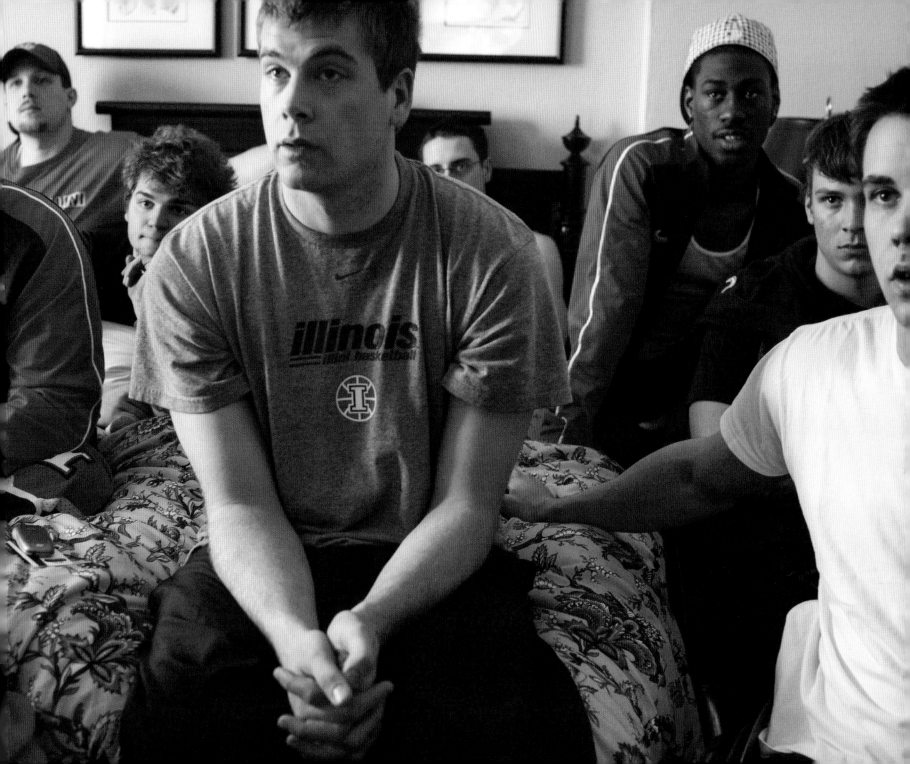

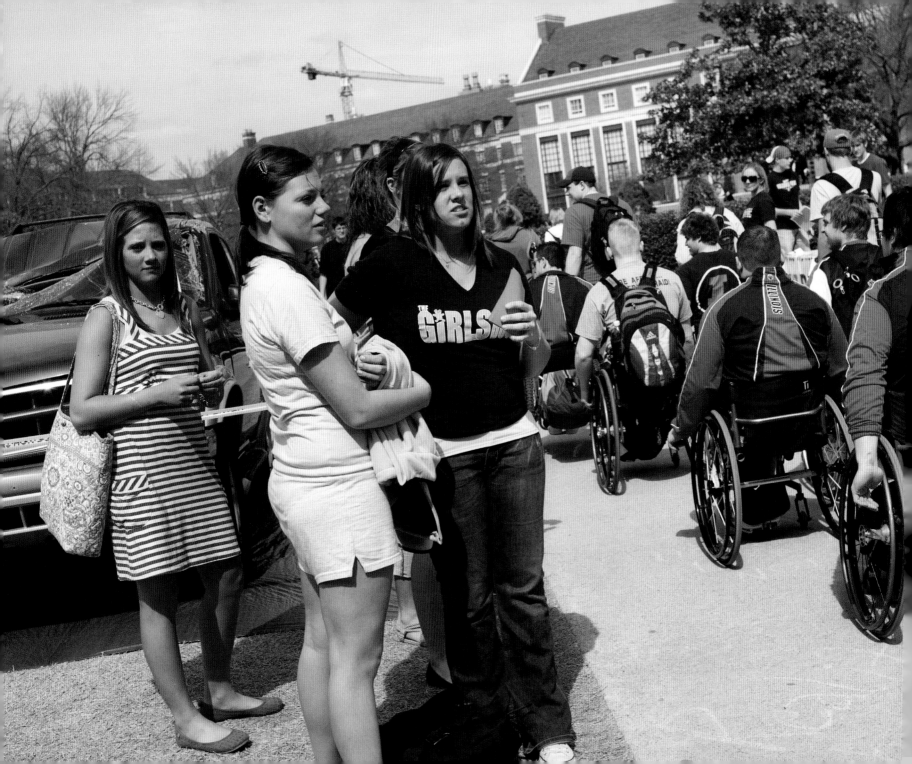

Players roll across the Oklahoma State University campus to the first match of the NIWBT.

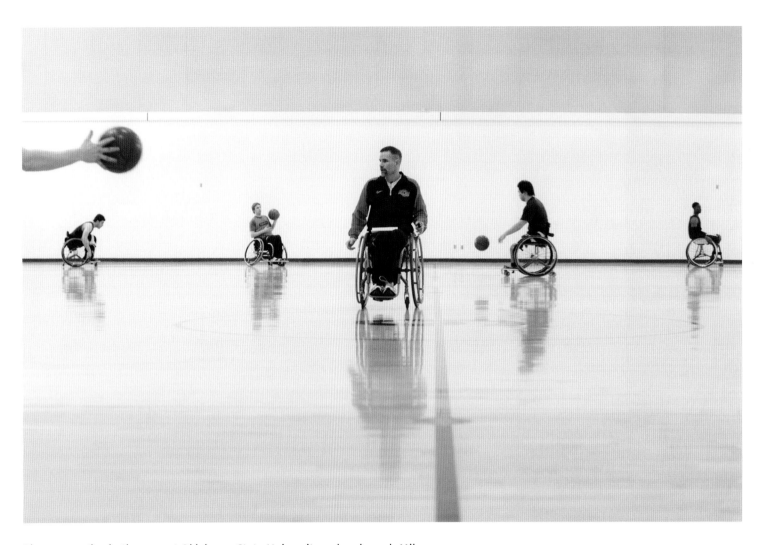

Players practice in the gym at Oklahoma State University as head coach Mike
Frogley watches. The team beat Missouri the day before, 28–4, and was
preparing to face Arizona. They ended up beating Arizona, 31–17, to advance
to the championship game. The Illini were the number-one seed going into
the tournament, but they were still considered the underdog to the Wisconsin-
Whitewater Warhawks, who had won the championship four of the past five years.

Brian Bell gets ready for the championship game of the NIWBT on March 15, 2008.

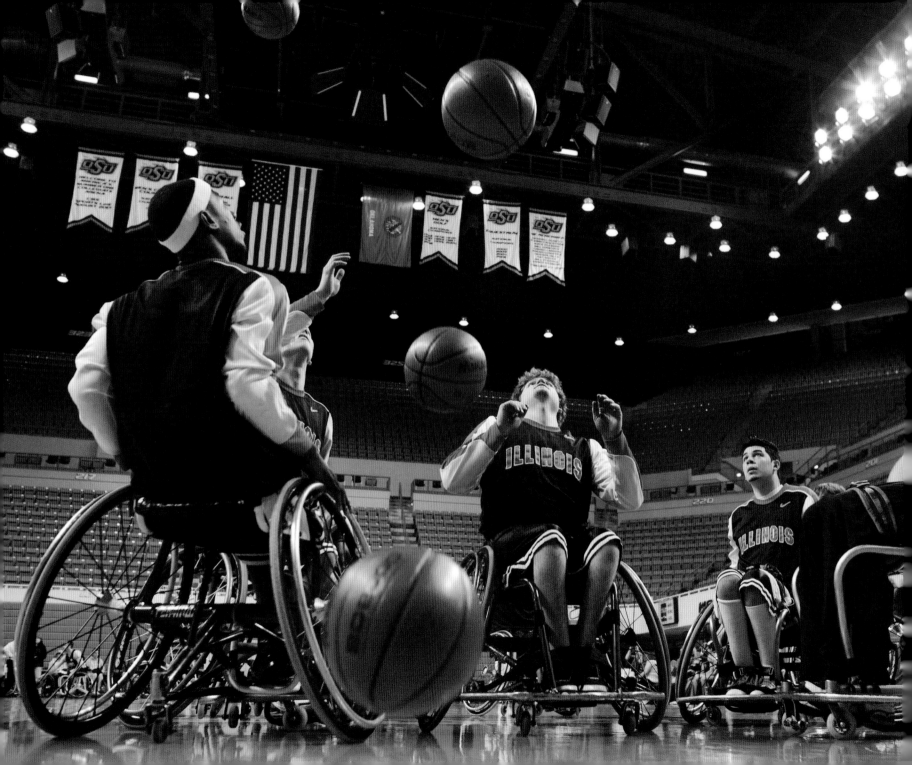

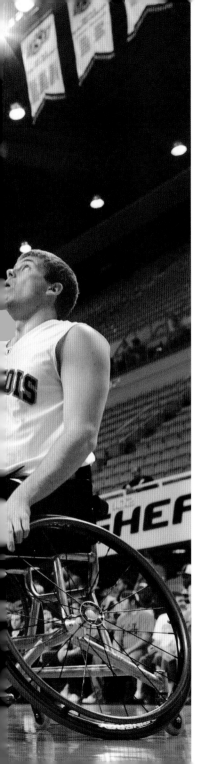

"

We have our confidence back; we don't feel like underdogs. We feel like we're the more powerful team.

"

—Tom Smurr

From left, Brian Bell, Joey Gugliotta, Jaime Baltazar, and Lars Spenger practice shooting before the championship game against Wisconsin-Whitewater at the 2008 NIWBT.

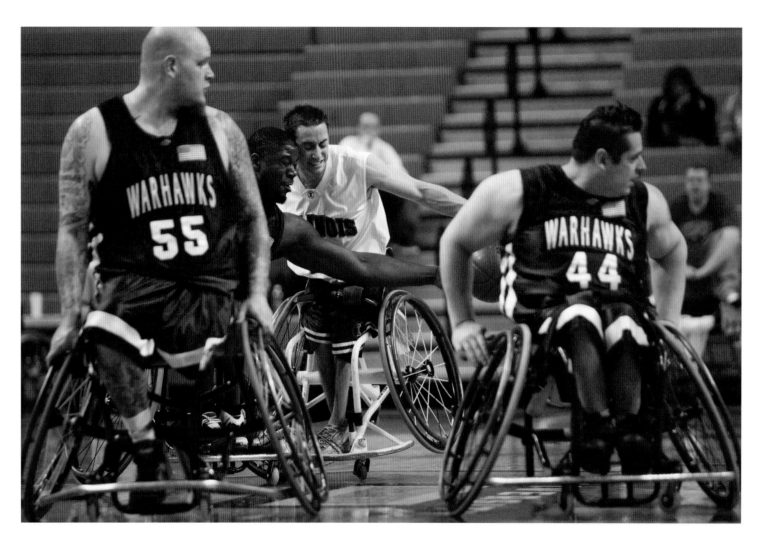

Illinois's Steve Serio fights for the ball with Wisconsin-Whitewater's Matt Scott as Joseph Chambers, left, and Jamie Mazzi look back during the championship game. "Captain Steve Serio has really come of age," head coach Mike Frogley said. "He has really become the player on the court that dictates the game."

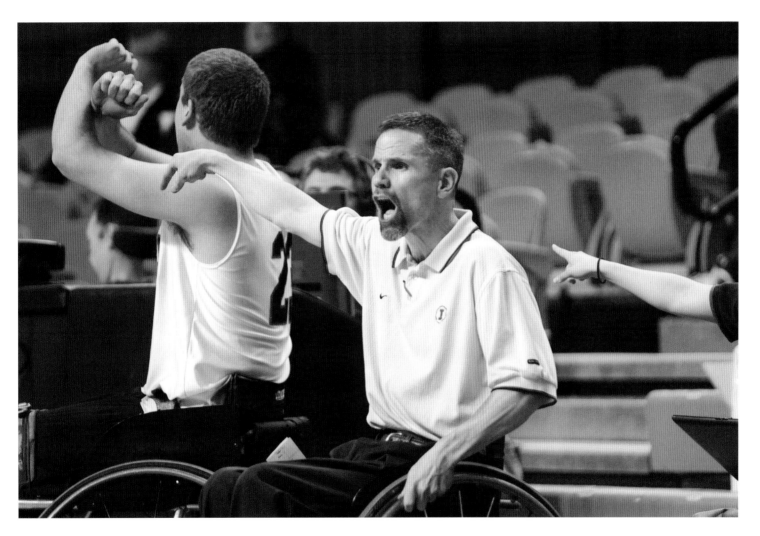

Head coach Mike Frogley yells about an intentional foul from a Wisconsin-Whitewater player during the championship game.

"

You're just looking around and you're like, 'Holy shit, there's like eighteen thousand threats out here and I don't know what to do.' It's hard to defend a team like that. But every single punch Whitewater threw at us we hit back. We just kept punching.

"

—Steve Serio, team captain

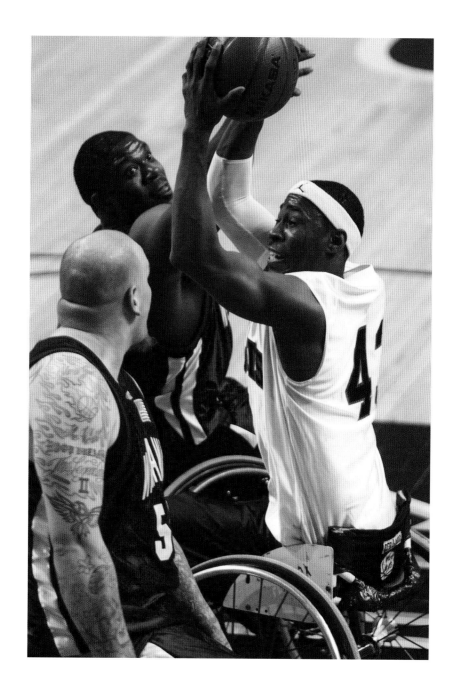

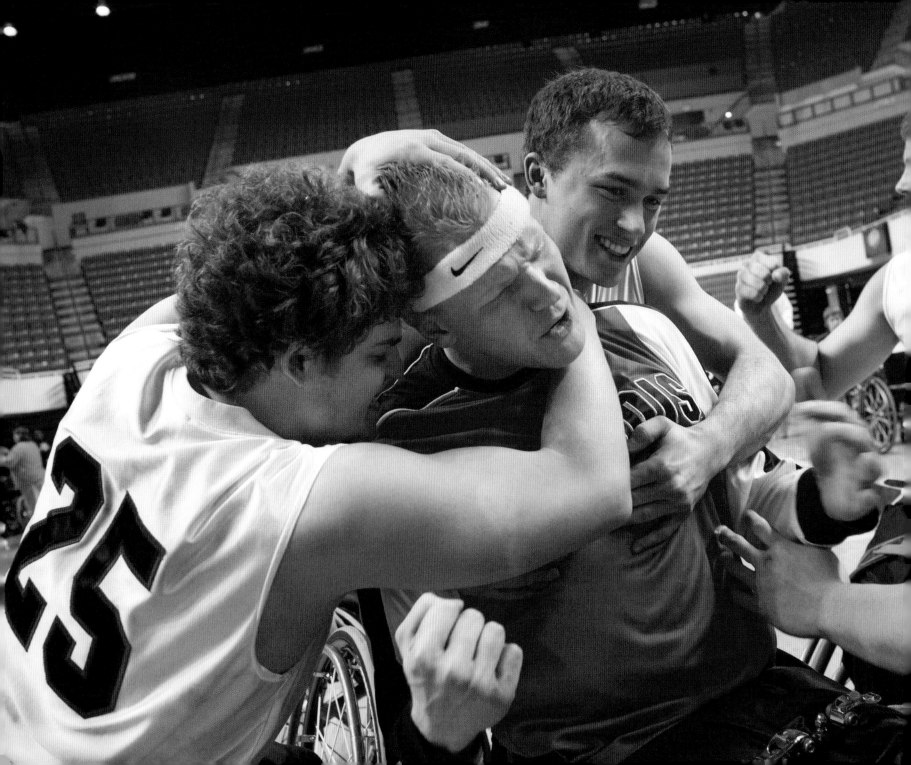

From left, Joey Gugliotta, Matthew E. Buchi, Tom Smurr, and Lars Spenger celebrate after Illinois defeated Wisconsin-Whitewater, 63–58, to win the 2008 National Intercollegiate Wheelchair Basketball Tournament championship.

Drew Dokos celebrates the team's win atop the basket. The championship title was the first for the Illini men since 2001. It was also the first time since 1990 that both the Illini men and women claimed titles.

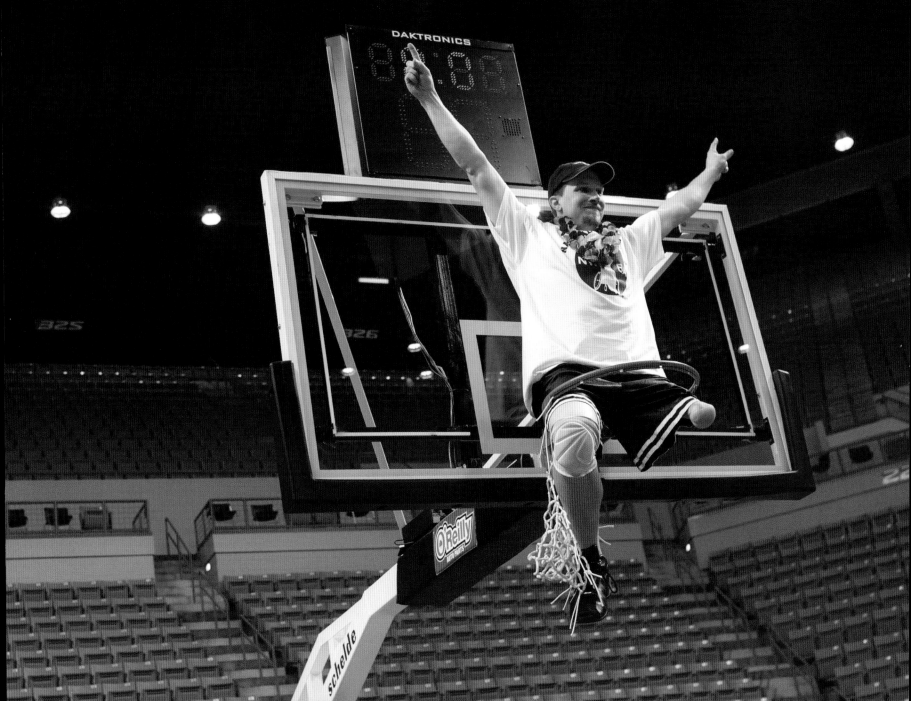

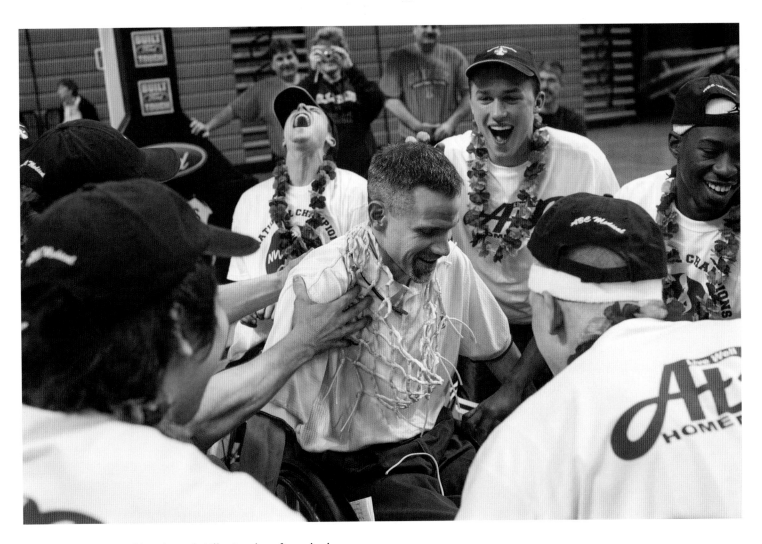

Players center around head coach Mike Frogley after winning the NIWBT. "Every single person did something to win this championship," team captain Steve Serio said. "If it wasn't people scoring, it was people getting some big defensive stops, and that's exactly what we needed."

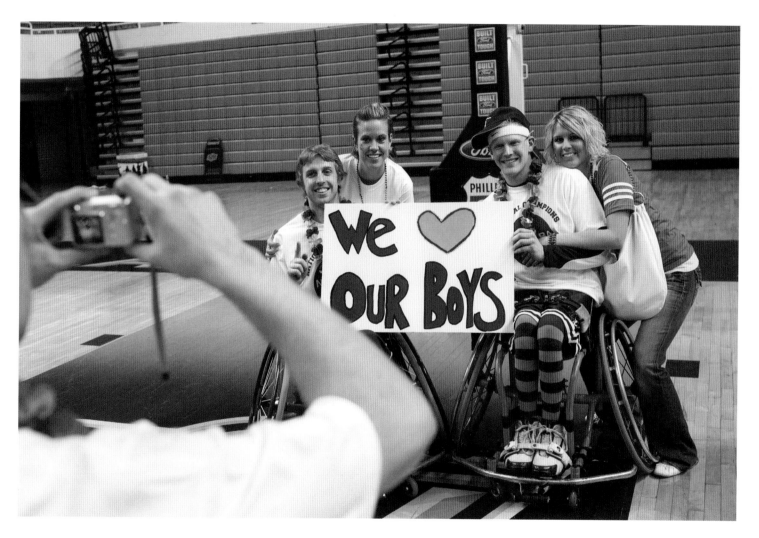

Brandon Wagner, left, and Matthew E. Buchi take pictures with their girlfriends, Fiona Soderberg and Kris Wallace, respectively, after winning the championship game.

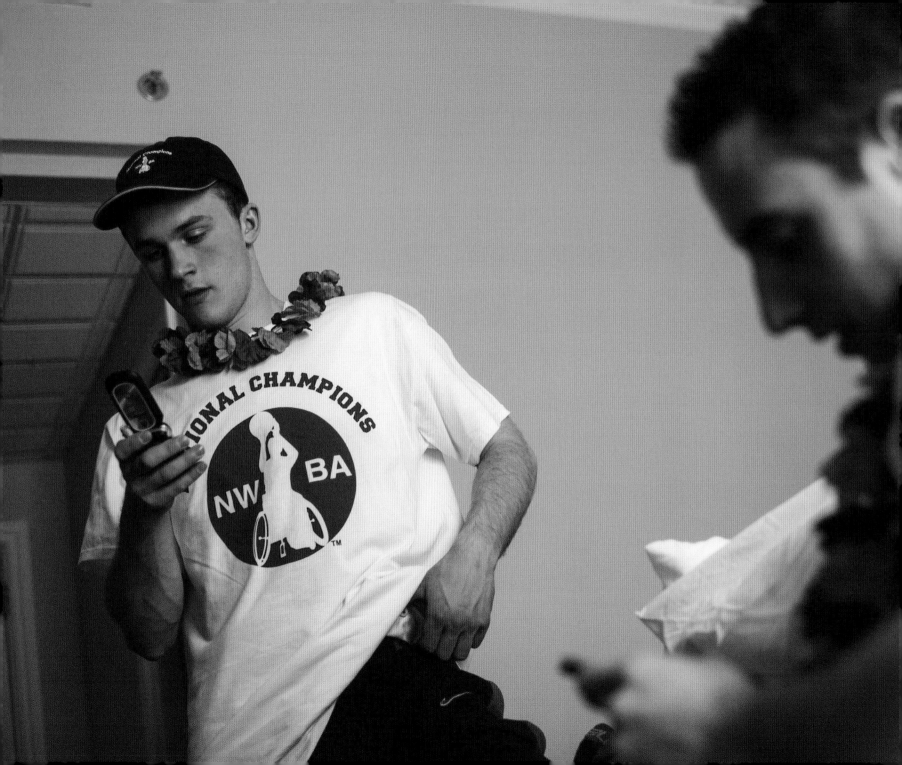

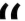

"People don't think wheelchair basketball is anything special, but we worked our asses off. We're the best team in the country.

"

—Joey Gugliotta

Tom Smurr, left, and Steve Serio text family and friends about the championship win from their hotel room later that day.

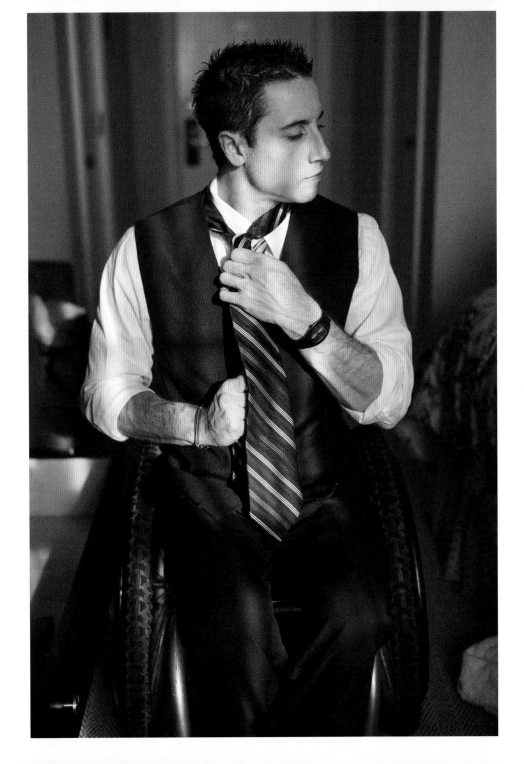

Steve Serio gets ready for the NIWBT banquet after the team's championship win.

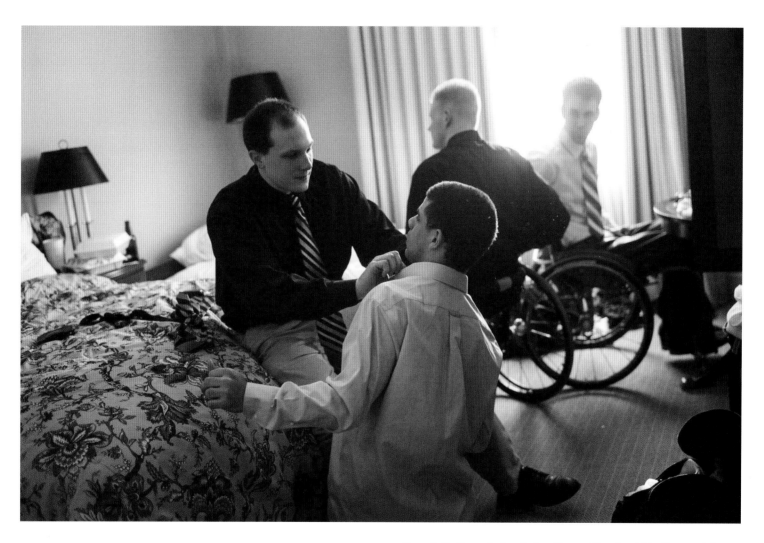

From left, Drew Dokos helps Steven Kouri get his tie on while Matthew E. Buchi and Aaron Pike get ready for the NIWBT banquet after the team's championship win.

Head coach Mike Frogley waits for players to gather in the lobby of the hotel so they can all attend the tournament banquet.

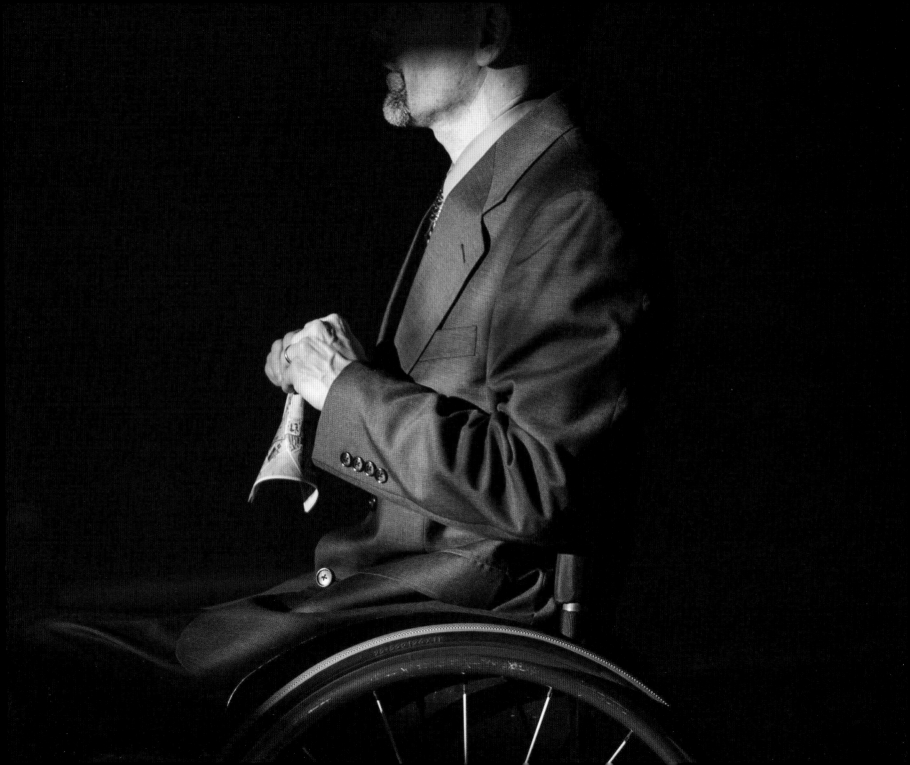

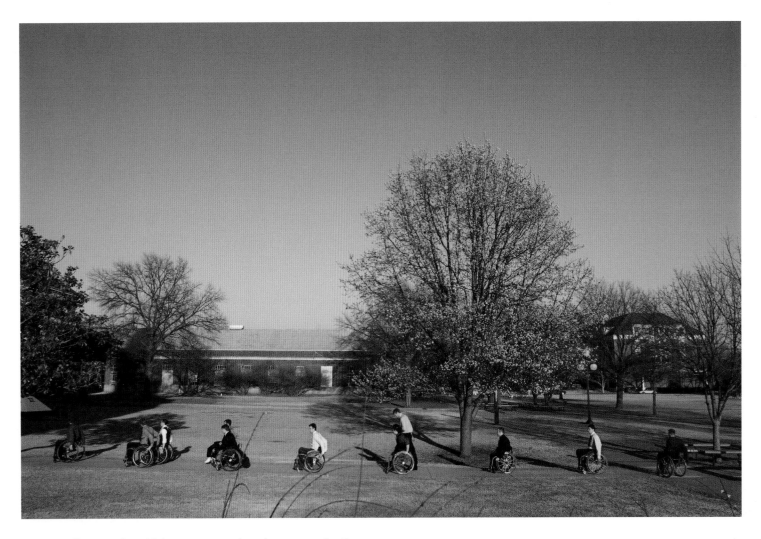

Players roll across the Oklahoma State University campus for the
NIWBT banquet.

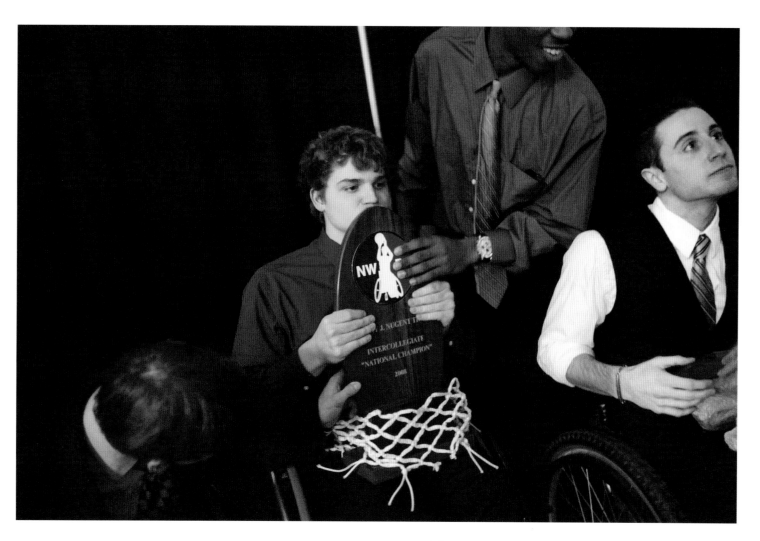

From left, Ryan Chalmers, Joey Gugliotta, Brian Bell, and Steve Serio celebrate their trophy win at the NIWBT banquet.

Tom Smurr and Jaime Baltazar proceed down the hallway of their hotel later that night.

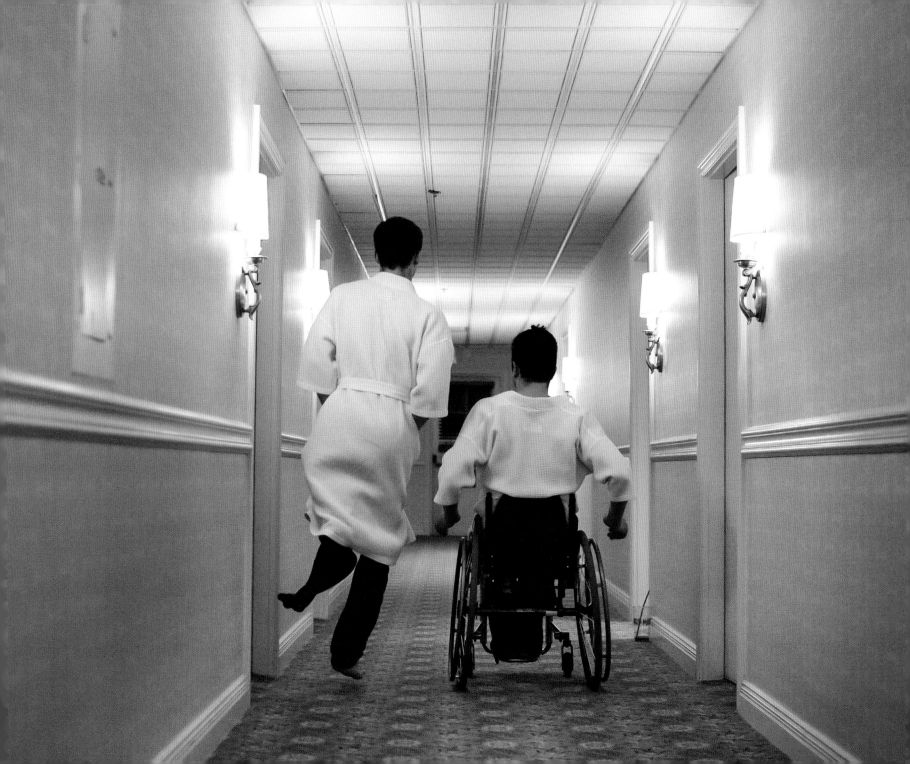

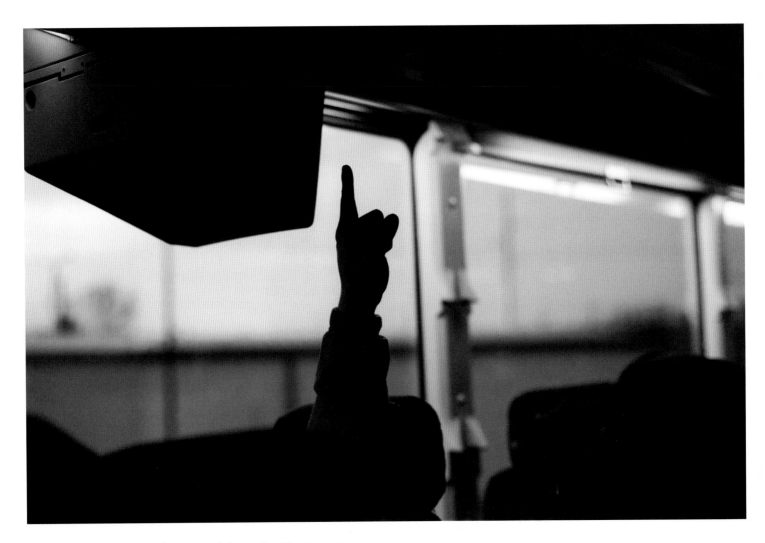

Peter Won raises a single finger to celebrate the Illinois men's wheelchair basketball team's championship title as they head back to Illinois.

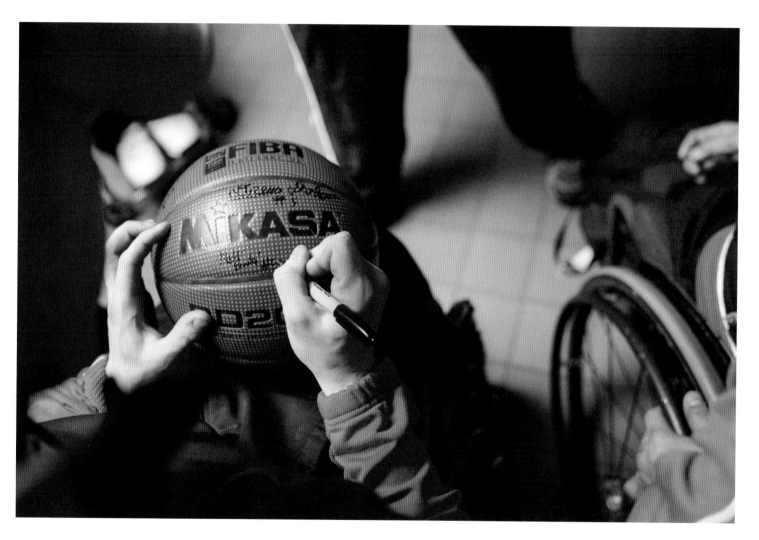

Matthew E. Buchi signs a memorial basketball for the Disability Resources and Educational Services facility after returning to the University of Illinois campus late at night.

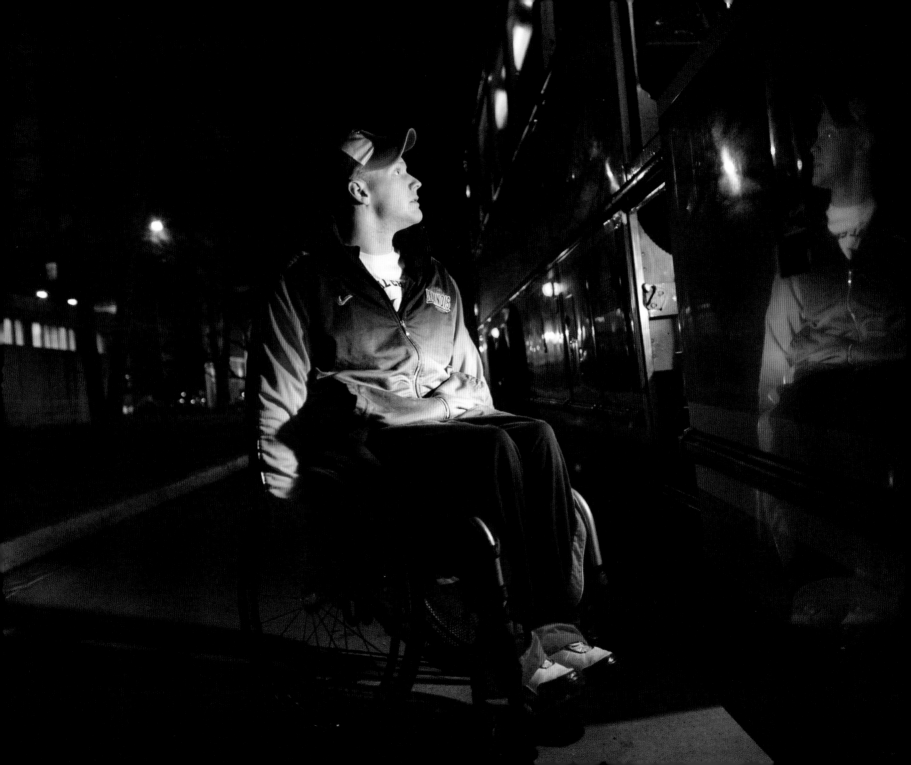

Matthew E. Buchi helps unload chairs, wheels, and bags after returning to the University of Illinois campus late at night on March 16, 2008. Five years later, in summer of 2013, Buchi would be appointed head coach of the Illinois men's wheelchair basketball program.

"

We're influential in every progression of wheelchair basketball. Every step of the way, U of I was right in the middle of everything, and we've always had great coaches and a winning tradition.

"

—Denny Muha

Epilogue

My undergraduate major was aerospace engineering. However, this did not deter me from pursuing my dream of becoming a photographer. While attending fluid mechanics classes and studying in compressible flow labs, I worked at the local camera shop—Bates Camera—and got my start as a staff photographer with the *Daily Illini*, the proud independent student newspaper of the University of Illinois at Urbana-Champaign.

In 2005, I received a simple assignment from my editor: photograph the Illinois wheelchair basketball game for Monday's paper. I wasn't even aware that we had a wheelchair basketball team; why had nobody told me? And why had I not seen coverage of them in local media? Certainly our men's able-bodied basketball team was getting a lot of attention: they remained undefeated nearly all year, with Dee Brown leading the Illini men to the NCAA championship game, where North Carolina handed them a crushing defeat. But there was nearly no coverage of the wheelchair team at the time.

I arrived at the assignment early to make some photographs of players interacting and preparing for the game. I observed their movements, the way they flowed down the court seamlessly on diagonally mounted wheels. I was mesmerized by certain

"In 2005, I received a simple assignment from my editor: photograph the Illinois wheelchair basketball game for Monday's paper."

personalities. As soon as the game started, I was drawn into the fast-paced action, the visceral energy on the court, the upturned chairs, the players' dirt-covered hands and torn bandages. I tried to figure out how the rules worked so I could understand what was happening to report in my captions. I made some decent pictures with my telephoto lens and stayed after the game to make some wider pictures up close. During the team huddle, I photographed and listened to the coach address an enthusiastic young boy on crutches. I also met a friendly man named Tim Nugent, who struck me as very kind and warm.

At the time of this assignment, I was itching to start a personal project. For a working photographer, the personal project is an outlet to tell an important story in-depth as well as share your personal vision with the world. When you're required to shoot assignments all day for other people (editors, reporters, clients), it can be refreshing and therapeutic to assign yourself to photograph something along the lines of your interest, and do so in the way you choose. I had been searching, and this wheelchair team seemed to fit the bill: a subject matter that I had not seen covered that was interesting, visual, and filled with human interaction.

I reached out to head coach Mike Frogley ("Frog"), who agreed to meet with me. We discussed my ideas, and he expressed concern over how I intended to portray the athletes. He was clearly wary of negative media coverage, which for decades had stigmatized individuals in wheelchairs. I was aware of this visual history and assured him that I was interested in the discrepancy between coverage of the able-bodied and wheelchair teams, and I intended to focus on the abilities of these student athletes, not the disabilities and differences. They were humans, athletes, and basketball players. Frog told me that practice was at 6:30 A.M. every morning, and I was welcome to attend as much as I wanted.

I showed up to practice the next day. My presence was announced, and the athletes were allowed to refuse to be photographed, but nobody did. Very quickly they went into their normal routines and I scurried around the gym observing, sensing, photographing. These individuals seemed to be very good at ignoring me, and this made it easy for me to be an element of the background for them. I could focus on photographing, and they would act as if I were not there. I distinctly remember the smell of sweat and burning rubber.

I doggedly showed up to practice every morning at 6:30 A.M., partially because I wanted to keep trying to make new photographs, and partially because I wanted them to see that I was dedicated.

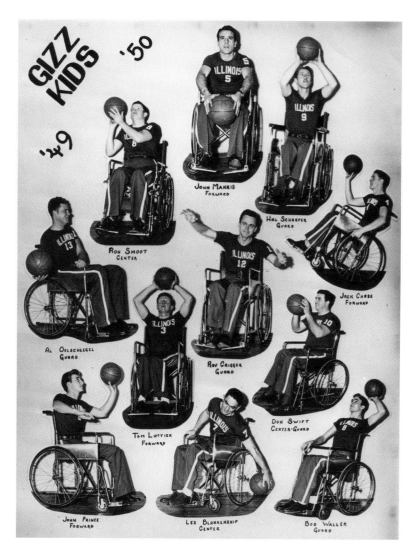

Illinois Gizz Kids team photo from the 1949–1950 season. *Photo #0004072 courtesy of the University of Illinois Archives at Urbana-Champaign.*

Soon players started engaging me in conversation and asking me about myself, always registering surprise at my background. We would talk about shared interests and joke together. My team nickname became "Rocket"—a humorous reference to my rocket scientist education. One morning I was even a bit late for practice, and as soon as I walked in Frog yelled at me for my tardiness. "Rocket, why are you late?" he exclaimed in front of everybody as I hurriedly got my gear ready. "Get with it!"

I had become a player on the team.

Around this same time, I began an independent study with Brian K. Johnson, a photojournalism professor at Illinois. He guided me in developing my pictures and the story I was trying to tell. He told me that in addition to photographing the team, I should focus on one player and dive into his life, to show viewers the parts of a player's life they normally cannot see.

Frog recommended I photograph the team captain, Denny Muha, who was also dating a player on the women's team, Amanda McGrory. Denny graciously put up with my incessant coverage: I followed him from practice to the gym, to classes, to home in the evenings with Amanda. We all bonded and became

friends. I got to know his best friend, Matthew E. Buchi, too. One day we visited Buchi at the hospital when he was fighting off a staph infection. I even photographed the group of friends partying on the weekends.

As I followed Denny, I continued to document the team for the 2005–2006 season. I followed them to away games on the bus, slept on their hotel room floors, and attended all team meetings. I didn't know what was going to happen one moment to the next, so I thought I should be present as much as possible, just in case a potentially important picture would happen. This is the mindset of an obsessed documentary photographer.

Time and dedication built trust. I developed deep relationships with many of the players, and when they see you as one of their own, they ignore you like they would a known piece of furniture in their living room. I worked to show everyone that I was dedicated to their story, I was willing to share, and I was interested in more than pictures. I wanted to get to know them, commune with them, to help share their story with the world. Over time, through conversations and demonstrated behavior, the players knew why I was there, and they believed in my presence

LEFT and RIGHT: Picture page from the *Daily Illini*, April 2006. *Printed with permission of Illini Media Company.*

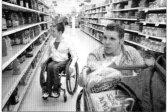

After playing two games in a row at Wisconsin on March 18, Denny's hands show calluses, peeling skin and caked-on dirt. His hands get dirty from pushing his wheelchair. "Some courts are dirtier than others," he said.

Denny and his girlfriend Amanda McGrory shop for food at Wal-Mart on March 6. Although Denny can hardly see over the edge of the cart, he has no trouble pushing it.

'There's not really anything I can't do'

PHOTOGRAPHS AND TEXT BY JOSH BIRNBAUM

Every morning, Denny Lee Muha, senior captain of the Illinois Men's Wheelchair Basketball Team, wakes up at 5:45 a.m. to arrive at practice on time.

After practice, he either has class or work, then lifting and finally he goes home to spend time with his girlfriend and study.

Denny's girlfriend, Amanda McGrory, is a member of the women's wheelchair basketball team and sophomore in LAS. They go to practice together every morning and have been dating for more than a year and a half. Because Denny and Amanda are both in wheelchairs "it's easier to deal with any disability related issues" Denny said. "I think it's easier because there's less to explain."

Denny and Amanda also work together at the Rehab Center in the next conversion department. They convert texts to PDFs and books on tape for disabled students to use. And his work schedule is flexible, too.

"My boss is awesome about giving me time off for tournaments or extra practices," Denny said. "Any other job, I wouldn't be able to just get time off when I need it. They're pretty strict about that. But she knows I'm an athlete and she knows my coach."

After work, Denny lifts weights for his daily workout at the Rehab Center. He finishes his day off with more classes and time with Amanda.

Denny has been playing with the team since his freshman year when he was a Parkland Community College student.

In his sophomore year, he transferred to the University and played with the team as a starter almost immediately.

"I first came here at Parkland. I got to practice with the team but I didn't get to play in any games ... and that was the most frustrating thing ever, just because I do all that work to practice and I don't even get to have any of the reward of playing," Denny said. "That's the reward of practicing hard: to use what you practice in a game. And so I'd just have to sit on the sidelines and watch and cheer and it was so frustrating. But I kept working hard, and once I transferred in I was pretty much a starter after the second tournament just because I was really familiar with everything (Coach Mike Frogley) does and I knew the players."

And Frog and Denny share a special relationship.

"Since I've gotten here, our relationship has definitely grown," Denny said. "He's definitely like a father figure in my life. I definitely look up at him and have so much

Follow their story

This is the second in a three-part series about the Illinois Men's Wheelchair Basketball Team.

Tuesday: The Illinois team.
Today: Team captain Denny Muha.
Thursday: The road to the national championship.

respect for him. He's always been there for me as a great coach, but he's always made sure that I know that if there's anything I need, he's always got my back on it. Anything at all."

And Frog feels the same way.

"I took on Denny ... I look on him like a son," Frogley said. "I love coaching him. There's a lot of parts of our personality that are the same."

Denny first started playing wheelchair sports in eighth grade after he was paralyzed from the waist down. He was born with Spina Bifida, a condition in which the spine is not fully developed. After emergency surgery, he was able to walk for the first eight years of his life.

When he was eight, doctors discovered that he had a tethered cord, which results from the cord becoming entangled with the scar tissue. After another surgery, however, he was not able to walk.

"I came to and I kinda noticed that I couldn't really feel my legs that well ... and the doctor tried to have me stand up. I went to stand up and I just fell on the floor," Denny said. "They don't really know exactly what happened, but we're just assuming that the doctor must have just touched my spinal cord and I got paralyzed from that."

Denny did not let that stop him from living a normal life. Denny said he recalls one time changing a lightbulb on the ceiling by putting a chair on top of his bed.

"That's just the kind of person I am," Denny said. "I try to find a way to do things. There's not really anything I can't do, but I'll find a different way to do it somehow."

Despite his disability, Denny is overwhelmingly positive about his life — what he has accomplished and where his disability has led him.

"Wheelchair basketball has gotten me so far, and I've met so many people and done so many things that I wouldn't gain anything from being able to walk," Denny said. "It just isn't worth it."

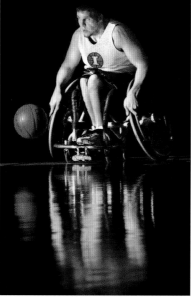

Denny Lee Muha practices in the morning light at CRCE on Feb. 24. Denny is a senior in ALS and is one of the team captains.

Denny kisses Amanda before they go out to Joe's Brewery for another team member's birthday on Feb. 26 at Amanda's apartment. They have been dating for a year and a half.

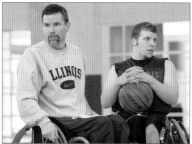

Denny and Coach Frogley share a special relationship. To Denny, "He's like a basketball coach, and it's kind of corny, but he's like a life coach." To Frogley, "There are a lot of things that are the same between the two of us."

'You should have to sacrifice'

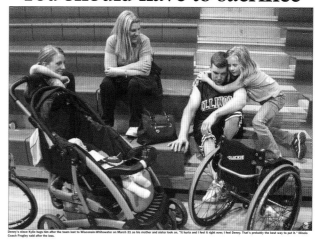

Denny's niece Kylie hugs him after the team lost to Wisconsin-Whitewater on March 31 as his mother and sister look on. "It hurts and I feel it right now; I feel Denny. That's probably the best way to put it." Illinois Coach Frogley said after the loss.

PHOTOGRAPHS AND TEXT BY JOSH BIRNBAUM

All their work was for one thing: the National Intercollegiate Wheelchair Basketball Tournament, to be hosted by the University of Illinois at the end of March.

This was the national championship for collegiate wheelchair basketball.

Team Captain Denny Muha and the rest of the team had been preparing all year. They had even devoted their spring break to practicing — two practices, video sessions and weight lifting every day.

"They don't have anything else to do but get ready for nationals now," Head Coach Mike Frogley said. "If they're not willing to do the work, then we shouldn't win a championship; we shouldn't be given it. It should be something that you earn and it should be difficult to achieve. You should have to sacrifice."

The week of the championship came and they felt more prepared. They knew they had worked hard enough; they had done all they could to prepare.

> "It should be something that you earn and it should be difficult to achieve."
> — MIKE FROGLEY
> HEAD COACH

The tournament began March 30 and the team played its first game against Southwest Minnesota State University on March 31, winning the contest 64-42.

But the team's biggest challenge was to come later that night when it was to play Wisconsin-Whitewater, the squad that had beaten them twice just two weeks before. This was the game that would determine if Illinois would move on to the first place game.

The game began, and the Illini were ahead 22-16 at the half. They stayed ahead until the last five minutes of the game, when Wisconsin overcame them. Illinois lost, 45-52.

Denny and the rest of the team were extremely disappointed, but they had another game to play the next day against Edinboro to determine if they earned third or fourth place.

"It hurts and I feel it right now; I feel Denny. That's probably the best way to put it," Frogley said after the loss to Whitewater.

However, the team came in the next morning refreshed and ready to play basketball and it defeated Edinboro 65-54 to earn third place, a place better than last year.

"It felt great," Denny said. "We played so well versus Whitewater — we played one of our best games of the year and we peaked at the right time. That's what's most frustrating about it is that every team, they want to peak at the exact right time so they can be playing their best basketball at the end of the season.

"That's exactly what we did — we were so prepared for that game and to lose that game was heartbreaking, but we knew that we didn't have time to dwell on it and we couldn't just hang our heads and feel sorry for ourselves, because Edinboro was waiting for us," Denny continued.

"I was upset for that night and I woke up the next morning and it was just all about Edinboro and just getting ready for that game."

Frogley said he felt the same way.

"We stepped and we grew from yesterday to today," Frogley said. "We grew ... we wanted 50 hours of our best basketball, we wanted to be able to play our best game. we wanted to do what champions do. I think we learned how to do that, I think we learned how to do that today."

And the team is excited about next year, too, because they aren't losing any players and are gaining some new recruits.

"I was talking to (Whitewater Coach) Tracy at half court after the game," Frogley said to the team after the tournament. "He's like, 'Hey next year, you and I championship game.' I said, we'll be there. We'll be there. Make sure you can carry your end of the bargain.'"

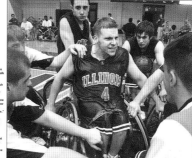

Denny paces around the outer hallways of Huff Gym before the team plays Wisconsin-Whitewater. This was the game that would determine if they moved on to the National Championship game.

(Left) Denny gives the team a pep talk before the big game against Whitewater. Coach Frogley also prepped them for the game by saying, "Let's show 'em that, you know what, they bleed like everyone else."

(Far right) Denny tries to keep the ball away from Edinboro's Jose Leep during the game on April 1 at Huff Gym. Illinois won, 65-54, earning third place in the national tournament.

Men's wheelchair basketball dominates tourney at Mizzou

Experience and team chemistry render Illinois team victorious across the U.S.

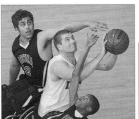

Cam Spenger shoots the ball over Arizona defenders during the tournament Saturday.

Head coaches Patty Cisneros and Mike Frogley work on the bus ride home Saturday.

PHOTOS AND STORY
BY JOSH BIRNBAUM

The Illinois men's wheelchair basketball team dominated all competition at a University of Missouri tournament this past weekend, winning all four of its games by a margin of at least 13 points.

The Illini opened against the University of Alabama, forcing 24 turnovers and winning 73-59. Later, they defeated Missouri 77-58.

"You can really see on the court that the trigger for our game is our defense," head coach Mike Frogley said.

"When we come out and we're playing good defense together, we force other teams to make bad passes and bad shots."

Playing those younger and less-experienced teams allowed Frogley to give playing time to some of his rookies, like freshman Tom Smurr.

"Even though it's a younger team and they're not necessarily as difficult as other teams, it still requires us to play the game," said Smurr, who contributed six points, three rebounds and four steals in the Missouri game.

"It's more or less a mind game — trying to keep ourselves mentally prepared for the next game."

The Illini also played more experienced opponents, besting the University of Texas-Arlington and the No. 3 University of Arizona, 67-47 and 63-50, respectively.

Freshman Brian Bell scored 26 points against Arizona, and team captain Steve Serio netted 22 points against UTA and 20 against the Wildcats.

"Steve is always important because he runs the show out there," Frogley said.

"But whoever gets open on offense seems to be the one that scores and rises to the occasion."

Serio agrees that every member of the team contributes to the wins.

"We have so much talent on this team, now it's just figuring out how to make everyone's talents come together," Serio said.

Illinois will travel to Canada this weekend to face off against the Canadian and Japanese national teams, which will be a challenge because it will be playing under international rules.

"We're used to a 35-second shot clock ... we're going to be playing with a 24-second shot clock," Frogley said.

"It's going to push us a lot and force players to play at a much higher level much more quickly."

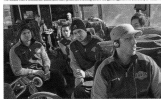

The Illinois men's wheelchair basketball team practices shooting before the game against the University of Texas-Arlington on Feb. 1.

(Left) Joey Gugliotta gets ready to jump into the pool from a table as Brian Bell helps weigh him down on Feb. 1.

Brandon Wagner, right, and teammates wait for the bus to leave for the gym on Saturday.

Brian Bell rests after coming out of a Burger King play pen adjacent to the hotel on Feb. 1.

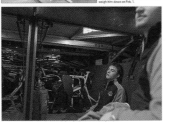

Tom Smurr rests from loading wheels onto the bus after the tournament on Saturday.

Women war with men over weekend

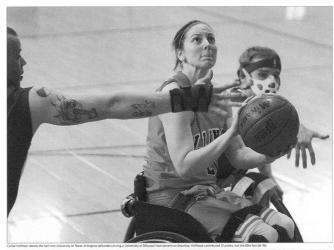

Carlee Hoffman shoots the ball over University of Texas-Arlington defenders during a University of Missouri tournament on Saturday. Hoffman contributed 21 points, but the Illini lost 66-50.

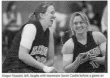

Megan Nyquist, left, laughs with teammate Sarah Castle before a game on Feb. 1.

Sarah Castle, center, and Megan Nyquist, right, play with Macy Frogley, daughter of men's head coach Mike Frogley, on the bus Saturday.

Kathleen O'Kelly-Kennedy pushes Joey Gugliotta, center, as Brielle Kean, left, and Shawna Culp, right, help other athletes up a hill after dinner on Jan. 31.

Amanda McGrory rests between games at the tournament on Feb. 1.

PHOTOS AND STORY
BY JOSH BIRNBAUM

For the second weekend in a row, the Illinois women's wheelchair basketball team competed against all men's teams, winning a 54-53 game against the University of Missouri and barely losing to the University of Alabama 51-49.

"A lot of men play really flashy, but the women played more like a team and we definitely showed that this weekend," senior captain Carlee Hoffman said. "We came out on fire, we shot really well and we just played fundamental team basketball."

Indeed, the Illini women shot 46.4 percent to Missouri's 26.4 percent, and despite losing the game against Alabama, shot 46.9 percent from the field compared to Alabama's 35.8 percent.

Hoffman scored 20 points in the Missouri win and 25 points against Alabama, shooting 10-for-13 in the latter game and making all four of her three-point shots.

"[Hoffman] really worked on her three-point shot," head coach Patty Cisneros said. "She was clutch ... she had an awesome tournament."

In addition, the women played the University of Arizona and the University of Texas-Arlington, losing 73-58 and 66-50, respectively.

Cisneros said that she used the tough competition to get some of the younger players more experience since the team will lose some seniors this year. Freshman Shawna Culp saw minutes in every game and tried to work on taking on different roles on the court.

"I'm not a big post player, per se, and I'm not a short, fast ball handler," Culp said. "I kind of have to play all those roles if I'm

needed there."

Despite some tough losses in the past few tournaments, the team will be playing women's teams once again at the Denver Invitational tournament this weekend.

"We came out of this tournament with a bigger understanding of what we can do, and not just against men's teams," Hoffman said. "We still have to prove to those girls that they can't touch us, that we're just so strong and solid."

The Denver tournament will be the last away tournament for the team as the women's national tournament is coming up at the end of the month.

"The fact that it's getting closer really makes us push harder the last stretch to get as good as we can, as fast as we can," Culp said.

Women's head coach Patty Cisneros yells at her players during a game on Feb. 1.

and purpose just as much as I did. Access to the men's team was generous, and I used that privilege with the utmost caution and care. I was there for great celebratory moments, like when they won big games, and somber moments of defeat when they lost majorly to a lower-ranked team in a championship series. They understood I was there to tell the real story of their existence, and not a candy-coated version with only smiles and wins. I took photographs during many challenging moments. There were times, however, when players did not want photographs taken, and I respected that.

At the end of the 2006 season, I documented a disappointing loss in the championship series, when the team ultimately got fourth place. After this, from all of my independent coverage, I put together a three-part series that ran in the *Daily Illini*. One part focused on the team, the next installment took us into the life of a single player, and the final piece documented the championship series through that player's eyes.

The picture pages that ran received a lot of positive feedback. People told me that they weren't aware of the wheelchair team's existence and that they followed the series day to day to see how the team fared in the championship. The players seemed to really appreciate the attention, and they loved the photographs. I put together a slideshow for their end-of-year banquet to help them celebrate their lives through photographs.

Although the end of the season seemed like a natural end to the project, I happened to have a tenacity problem. At the start of the 2006–2007 season, I came back to practice and continued photographing. In thinking about my larger goals for this project—beyond making pictures for myself and my portfolio and the athletes—I wanted to continue to cover the men's and women's wheelchair basketball teams in the *Daily Illini*. I knew I had to see it through. I argued and fought with my editors to get beat coverage for the wheelchair teams. Eventually the editors saw the value and agreed (or they saw the futility in trying to argue with me). With this newfound position, I wanted to treat the teams as we treated our able-bodied basketball teams, to help advocate for a more inclusive society and to raise awareness and appreciation of adapted athletics. After all, both the men's and women's team were historic, top-ranked teams. Why not showcase that heritage?

For the next two years I continued photographing, but I also interviewed coaches and players, gathered game stats, wrote

LEFT and RIGHT: Picture page from the *Daily Illini*, February 2008. *Printed with permission of Illini Media Company.*

stories, and published picture pages. This project ultimately taught me how to be a photojournalist.

As soon as the 2007–2008 season came around, factors were aligning for a promising year: they had lots of seasoned veterans, many promising new recruits, and gobs of enthusiasm. In March 2008, the women's team won its championship and set the stage for the men to do the same. I photographed their emotional win. Weeks later the men took the crown for the first time in seven years, a milestone accomplishment for the team and the individuals who had worked so hard to get there. The winning of the championship served as a natural end to the narrative of the pictures. It was fortunate because this was the year I graduated, and the last year I was able to continue my coverage.

Although I was pleased with the overall experience of documenting the wheelchair athletics program, I deeply regret not covering the women's team more. Unfortunately, I was not granted access to the team quite like I was the men's team. Because I was an undergraduate male, there were concerns about making the women uncomfortable with my immersive documentary coverage (in locker rooms, on the bus, in hotels, etc.). I wish I had pushed for more access so that the book could feature both teams in a balanced way.

As much as I wanted to continue photographing, however, my graduation forced me out into the world. I completed some internships, went to graduate school, and then starting working as a freelancer and teaching photography. Before I knew it, I had unwittingly let the photographs marinate on hard drives in my closet for almost eight years.

Then in November of 2015, I saw the news of legendary disability advocate Dr. Timothy Nugent's passing. I was saddened and began to immediately reflect on my experience with the wheelchair teams. I was also aware that it was also the twenty-fifth anniversary of the Americans with Disabilities Act, a piece of landmark legislation that made it illegal to discriminate based on disability. The timing seemed right, so I reached out to the University of Illinois Press, and they immediately saw the potential for a book.

"I had unwittingly let the photographs marinate on hard drives in my closet for almost eight years."

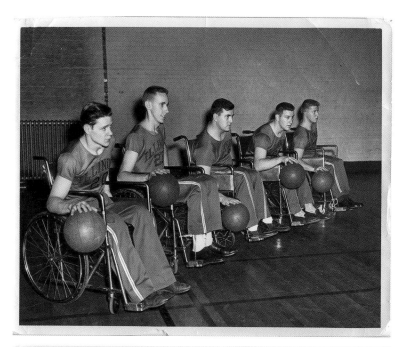

Editing this work was a challenge. I had to see my old mistakes (man, I had a lot of trouble focusing my cameras!) and deal with underexposure or images with sloppy compositions. But looking at each frame brought back a lot of the feelings associated with the time period, with the immensity of what I was witnessing. My editor, Stan Alost, worked tirelessly with me to pull out frames that I had previously missed, frames I didn't have the visual literacy or the prescience to understand eight years prior. Given the passage of time, my own personal growth, and the way that photographs as documents can accrue meaning, I was able to more fully see the overarching value in this work.

Dr. Nugent started the first collegiate team with the University of Illinois Gizz Kids in 1948. This book extends that legacy into the present day, showing the ripple impacts of his advocacy work and sharing a microcosm of the progress we've made. Through adapted athletics, those with disabilities—a group

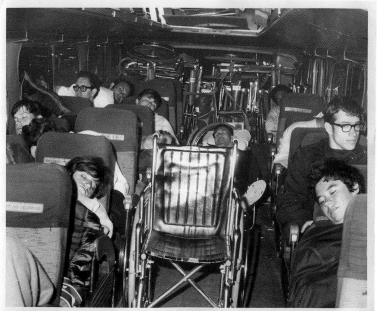

TOP: Illinois Gizz Kids dribbling, 1951–1952. *Photo #0003355 courtesy of the University of Illinois Archives at Urbana-Champaign.*

BOTTOM: Players sleep on the bus while traveling to national tournaments, 1970. *Photo #0003361 courtesy of the University of Illinois Archives at Urbana-Champaign.*

chronically ignored and discriminated against in our society—now have a chance to play. This photographic project turns attention to this group, saying: this is important; this deserves our empathy; this story needs to be told and seen and understood.

I seek to humanize individuals through personal photographs that share an insider's view into unique lives. I hope to show what it's like to be disabled and an athlete, but also to show commonality among human beings, to foster understanding more than emphasize difference. The work attempts to treat the wheelchair basketball team as a regular sports team, and this was my mindset the entire time while shooting: to shock viewers with the normality of their lives, while at the same time celebrating the unique aspects of their existences. Most of the documentary photography about wheelchair basketball currently focuses on action shots from games. My photographs are not taken from a spectator's point of view.

I immersed myself in these players' lives—an attempt to understand and share those findings with the world. I was different than most of the other media members who came to visit a practice to do a one-off story; I became an insider, a friend, a trusted confidant, a photographer who would spend the time to get to know them and their lives on a deeper level by living every moment with them.

I remember very vividly seeing the wheelchair basketball players interact with the general press; they always liked to challenge the mainstream media. During one particularly simplistic interview, a news reporter asked team captain Denny Muha, "What's it like having a disability?" Denny looked at the reporter with a straight face and said, "What disability?" He stared the reporter down, his seriousness not wavering one moment.

Such is the mindset of someone who hopes to defy perceptions of what it means to be alive and capable. This book attempts to break down the walls of age-old stereotypes and stigma in favor of a new, more accurate, fair, personal, nuanced narrative. This story, as well as the history of disability rights and adapted athletics, needs to be documented better to achieve this goal. The University of Illinois was at the nexus of much of this history. We need to harness this untapped history, preserve it, and change the accepted notions of our society, through photographs.

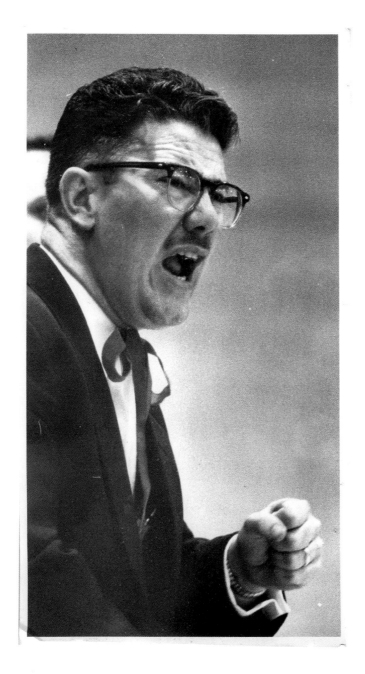

Dr. Tim Nugent—founder of the Illinois wheelchair basketball program and an ardent disability advocate—encourages players on court, circa 1960s. *Photo #0003385 courtesy of the University of Illinois Archives at Urbana-Champaign.*

"

That's just the kind of person I am. I try to find a way to do things. There's not really anything I can't do, but I'll find a different way to do it somehow.

"

—Denny Muha

Student at Lincoln Hall in wheelchair, circa 1957–1967. *Photo #0004011 courtesy of the University of Illinois Archives at Urbana-Champaign.*

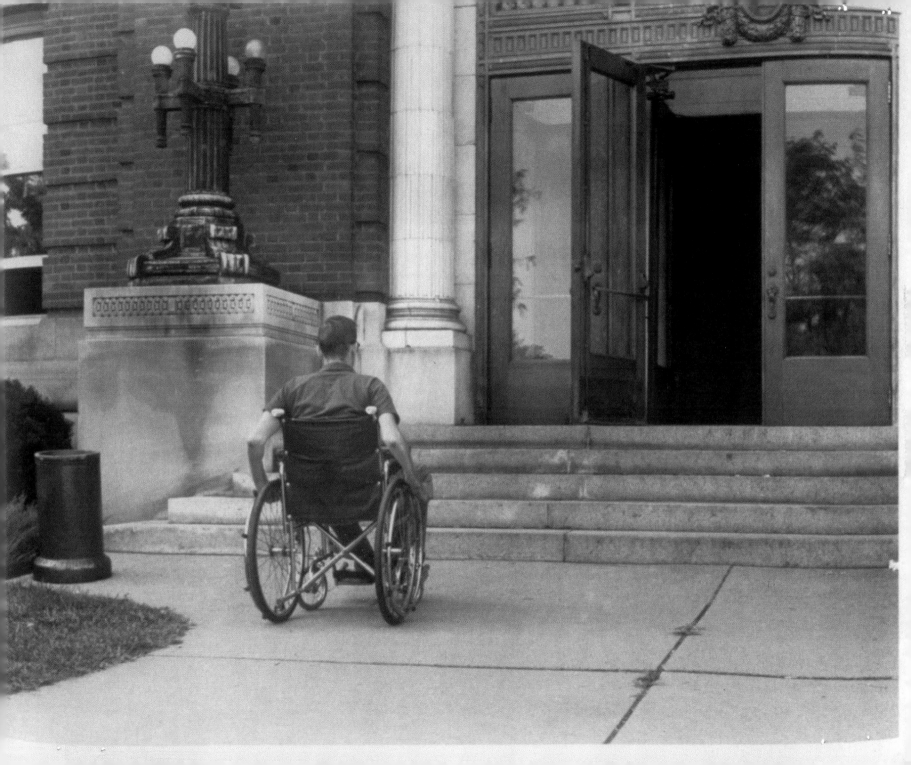

Acknowledgments

This book wouldn't have been possible without the help of numerous individuals and organizations.

First and foremost, thanks to Mike Frogley for believing in me just like he did for every one of his players. You always made me feel like one of the team. You listened to me, gave me access to talk to the players, and let me go on road trips with the team at a moment's notice. And, of course, thanks to the new head coach, Matthew E. Buchi, for writing a profound introduction and helping me organize all the details! Denny Muha and Amanda McGrory, thanks for really letting me follow you around and pester you with my camera. Everyone at DRES (Disability Resources and Educational Services), especially Maureen Gilbert, thank you for your help along the way.

All the players who gave me unfettered access to their lives, who let me take pictures at very uncomfortable moments, and who let me sleep on their hotel room floors—thank you. Agreeing to share your lives through pictures is a tremendous gift you have given us all.

Thanks to photojournalism professor Brian K. Johnson, who motivated me to start this project and guided me during a series of independent studies while at Illinois. BKJ, you rock.

A big thanks to my dedicated editor and guide, Stan Alost, who looked through every one of my 40,000-plus frames, who spent numerous weekends and evenings editing and designing to turn this into a book—thank you. I will never be able to repay you.

Thanks to the University of Illinois Press and my editor Michael Roux for believing in this project and the importance it has!

Nancy Crase, fellow photographer and cofounder of Sports 'n Spokes, it was great meeting you on the road, and thank you for all the advice over the years.

Thanks to friend and photographer Peter Hoffman, who said to me one day in 2007, "Man, you've shot so much for that project. One day you need to make a book out of it."

Thanks to my parents, Nita and Paul Birnbaum, and my grandmother Donna Biele, for making me into a curious and accepting individual! I wouldn't have had interest in such a project if you hadn't raised me the way you did.

David Zalaznik, Scott Bort, Mitch Ziegler, Bernard Fallon, Steven Turrill, Terry Eiler, Julie Elman, Alysia Burton Steele, Babz Jewell, John Agnone, Ross Mantle, and David Guttenfelter—you all played a part along the way. Thank you.

A huge thanks to my sponsors, who made the cost of producing this book feasible: ABC Medical, as well as Ohio University's Office of Research and Sponsored Programs, Scripps College of Communication, and the School of Visual Communication.

And finally, thank you, Dr. Nugent, for all you've done for countless individuals and for our society as a whole.

164

Index

JOSH BIRNBAUM is a lecturer in the School of Visual Communication at Ohio University.

SPONSORS

School of
Visual Communication

The University of Illinois Press
is a founding member of the
Association of American University Presses.

Photographs edited by: Stan Alost and Josh Birnbaum
Text designed by Josh Birnbaum and Kirsten Dennison
Composed in Milo OT and Museo Sans
by Kirsten Dennison
at the University of Illinois Press
Cover designed by Dustin J. Hubbart
Cover photo by Josh Birnbaum
Manufactured by Versa Press

University of Illinois Press
1325 South Oak Street
Champaign, IL 61820-6903
www.press.uillinois.edu